IMAGES
of America

SAN FRANCISCO'S
HAIGHT-ASHBURY

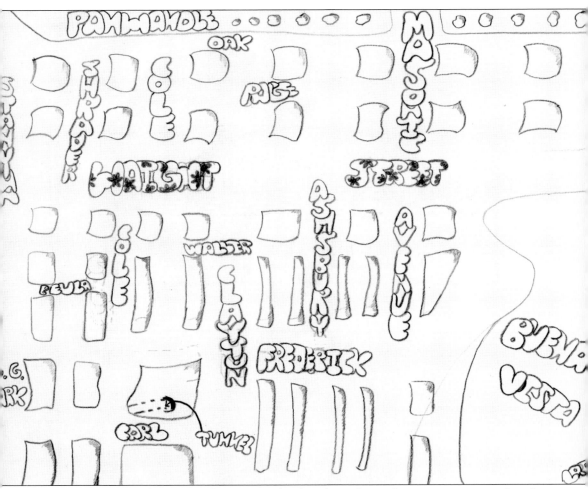

This map, drawn by a 1970s elementary school student, shows the primary streets referred to in this history of the Haight-Ashbury District. (Courtesy of a private collector.)

IMAGES

of America

SAN FRANCISCO'S
HAIGHT-ASHBURY

Katherine Powell Cohen

ARCADIA
PUBLISHING

Published by Arcadia Publishing
Charleston SC, Chicago IL, Portsmouth NH, San Francisco CA

Printed in the United States of America

Library of Congress Catalog Card Number: 2008934834

For all general information contact Arcadia Publishing at:
Telephone 843-853-2070
Fax 843-853-0044
E-mail sales@arcadiapublishing.com
For customer service and orders:
Toll-Free 1-888-313-2665

Visit us on the Internet at www.arcadiapublishing.com

*To all the souls who have touched and have been touched by the
Haight-Ashbury, especially Ron*

CONTENTS

ACKNOWLEDGMENTS

I owe an enormous debt of gratitude to historian and archivist Greg Gaar, a remarkable fellow. I am grateful also to Larry Holben and Dave Singer of All Saints Episcopal Church and to the Reverend J. Cameron Ayers, S.J., and Zack Zweber of St. Agnes Roman Catholic Church for their generous help. My thanks, as well, to Darice D. Murray-McKay of the Park Branch Library and Jocelyn Saidenberg of the San Francisco History Center at the main San Francisco Public Library for their kind assistance. I greatly appreciate the support and understanding of Jeremy Bates, editor of the *Haight-Ashbury Beat*, and Josefina Krieger Bates. Historian Timothy Keegan gave me valuable advice and encouragement. Thanks also to Don McLaurin and all the San Francisco City Guides volunteers who work to keep history alive in the Haight-Ashbury District. I'm thankful to Bruce and Steve, co-owners of Roberts Hardware, for adding a valuable piece of history. Unless otherwise noted, all images appearing in this book are from a private collector who wishes to maintain anonymity.

To my editor, John Poultney, I offer my sincere thanks for helpful guidance, a calming demeanor, and remarkable patience. A hippie at heart, John is one of us "late boomers" who missed the 1960s by accident of birth but who still managed to "hang in the Haight" a time or two. Having an editor who was hip to the Haight made this project all the more enjoyable.

To my dear husband and daughter and beloved parents, thank you for your enduring love and for providing me with the time I needed to do this work.

INTRODUCTION

It is a common sight: visitors and pilgrims of all ages—some wearing tie-dyed t-shirts, Indian prints, and love beads, others in pastel sweatshirts and jeans, and still others decked out in the gear of stylish world travelers. They come from the Midwest, from Manhattan, from the mid-Atlantic states. They come from Germany and France, from Japan and from Wales, from Australia and from Virginia. Families come with young children. They take photographs of one another at the famous intersection of Haight and Ashbury Streets. Many walk a block and a half up the hill to pay homage at the former home of the Grateful Dead, musicians who helped define a subculture. Young people, the women in long patchwork skirts and peasant blouses or sweaters and corduroy pants, also come, taking a gap year before going to university, or experiencing a less clearly defined journey. They bring guitars, dogs, and backpacks. A visit to the Haight-Ashbury District is a pilgrimage, and for many visitors, the neighborhood has become home.

What would the 19th-century dairy farmer William Lange make of all this? When San Francisco became a booming city in the mid-19th century, the lands west of Van Ness Avenue were known as the Outside Lands. Lange was a German immigrant who, in 1870, purchased nine acres in this area of the Outside Lands and established a dairy farm. Eighty years after that, the Haight-Ashbury District emerged as perhaps the most famous neighborhood in the world. How would Lange and his beloved dog, Shep, react to the 21st-century scene on Haight Street? He'd probably have a host of questions, and the answers would include a natural disaster of enormous proportions, an economic depression, world war, and a social revolution.

Lange would find his house still standing sedately where it first stood. In fact, most of the houses in the neighborhood are very much the same as they were at the beginning of the 20th century. And, though the people look a bit different, they still share the everyday good will of neighbors committed to a very special place.

Time and again, Haight-Ashbury has weathered events both local and international and continued to maintain its beauty, charm, and complexity.

In the summer of 1970, when I was seven-and-a-half-years old, I visited San Francisco for the first time. My parents had lived there early in their marriage, 15 years before. Like many people, I fell in love with San Francisco, but unlike the baby boomers who were a few years my senior, I had to wait to realize my passion.

I carried a torch for San Francisco for 17 years, growing up on the Texas Gulf Coast and going to school in Philadelphia and New York City. When it came time to decide where to make my home, I freed myself from the seductive embrace of Manhattan and flew happily into the waiting arms of San Francisco, my long-lost love. We've been together ever since.

I remember that first visit in remarkable detail. One vivid memory is of standing atop the hill at Alamo Heights Park. Tourist are drawn there to see the facades of the famous "Painted Lady" Victorian houses, with the impressive city hall as a backdrop. However, my dad and I stood with our backs to those landmarks. As we looked toward the next hill to the southwest, Buena Vista, my father said, "Just over there, in the Haight-Ashbury, something very special has recently

happened." He told me about the Summer of Love, about the young people who went to the Haight-Ashbury District seeking a generous way of living. There were risks involved in such an endeavor, and some people were so afraid of those risks that the popular song about coming to San Francisco, wearing flowers in your hair, and meeting the gentle people there had been banned from radio play in some places. (The actual title of the song is "San Francisco [Be Sure to Wear Flowers in Your Hair]." John Phillips of The Mamas and The Papas wrote it, and it was performed by Scott McKenzie.) We didn't go to Haight Street on our family vacation. In 1970, the area had yet to recover from the aftermath of that momentous time.

In 1987, when I returned to San Francisco, I took an apartment up the hill from Haight Street. I have felt more at home in the Haight-Ashbury District than anywhere else I have lived, and as I write this in 2008, I am still living here, four short blocks from where I lived over 21 years ago. My husband and I walk with our daughter to the nearby elementary school like many parents in our community. Along with other Ashburians—single, married, straight, gay, young, old, and in-between—we live our daily lives feeling fortunate to be lingering on the sidewalk to chat on sunny days, taking a warm "cuppa" in a café with our neighbors on foggy mornings, and watching tourists and travelers and the down-and-out who come here for a myriad of reasons.

This book is a look at the Haight's remarkable history. Real love takes into account the whole object, not just what one prefers to see. I hope that my love for this neighborhood has allowed me to present a well-rounded picture of a remarkable place.

One

FROM DUNES AND DAIRY FARM TO POPULAR DESTINATION

Before becoming farmland, the area that became the Haight-Ashbury neighborhood was a windswept landscape of sand dunes and hills of chert, the local igneous rock. Archeologists have discovered evidence of human inhabitants in what is now San Francisco that dates back 5,000 years, to 3,000 BCE. By 1769, when the Spanish explorer Don Gaspar de Portolà arrived, the Yelamu group of the Ohlone, indigenous peoples of Northern California, were living in a few small villages in the comparatively warm eastern part of the tip of the Baja peninsula. The lands toward the ocean were less hospitable, and the area that would become the Haight was avoided by the Spanish settlers, who referred to it as *la tierra de las pulgas* or "the land of the fleas."

In 1821, when Mexico won independence from Spain, the area became part of the vast Mexican holdings. When non-Mexican settlers received news of impending war with Mexico, they claimed California as an independent republic. Twenty-seven years after Mexico had acquired the land, the war between Mexico and the United States ended with the signing of the Treaty of Guadalupe-Hidalgo on February 2, 1848. California was now officially part of the United States.

The following year, the Gold Rush brought thousands of newcomers, who lived primarily in the northeastern part of San Francisco. It would be more than 30 years before the Haight-Ashbury District would begin to become a neighborhood.

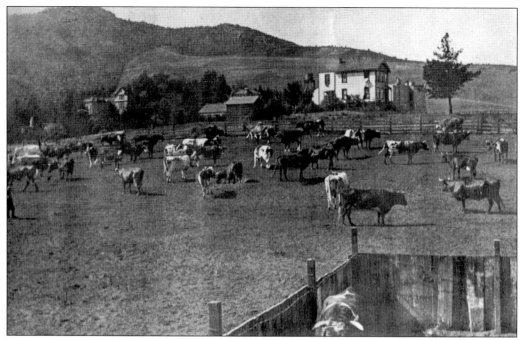

Twenty years after the Gold Rush, William Lange's dairy cows graze in what was then the countryside. This is the view looking westward toward Mount Sutro. On the mountain, Sutro Forest offers challenging trails. The lower slopes are now covered in Victorian houses, while just below the forest, the buildings of the University of California, San Francisco (UCSF) medical school overlook the area.

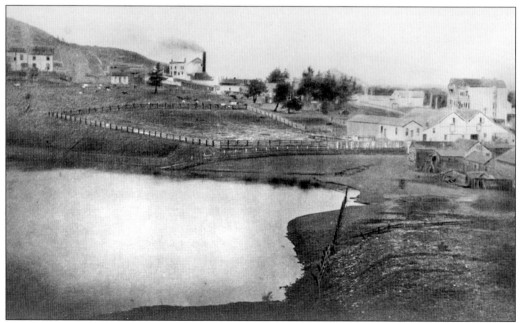

William Lange built up his dairy farm in the area that is now delineated by Cole, Carl, Stanyan, and Grattan Streets. Then part of the Outside Lands and considered by most to be too harsh to inhabit, this unlikely spot would become one of the most desired areas of the city.

Lange kept horses on his farm in the Outside Lands. The sandy soil here is a reminder that Golden Gate Park had yet to be developed. Once sand dunes were made stable with the use of ice plant, the park would draw visitors to the area.

Before the advent of the railway lines that would bring visitors from the northeastern part of the city, William Lange enjoyed the life of a country gentleman.

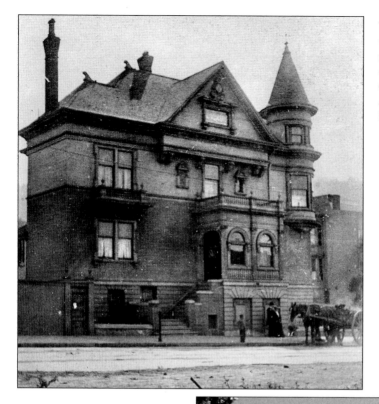

The Langes built one of the opulent Queen Anne residences that began covering the hills and dunes. Note the Queen Anne tower, with views to the northwest.

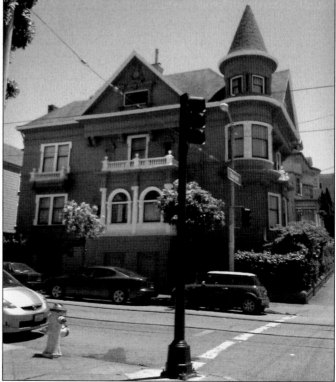

The Lange residence still stands at the corner of Stanyan and Carl Streets. The current owners have been in residence for over 60 years. (Photograph by K. Powell.)

In 1870, the same year that Lange settled in, changes began that would result in Golden Gate Park and the accompanying development of a neighborhood. Dr. Richard Beverly Cole (pictured here), San Francisco's first obstetrician, was among the city supervisors, who also included Monroe Ashbury, Charles H. Stanyan, and A. J. Shrader. Together they pushed for a large city park to be built in the Outside Lands, a proposal that was approved by Mayor Frank McCoppin in 1869.

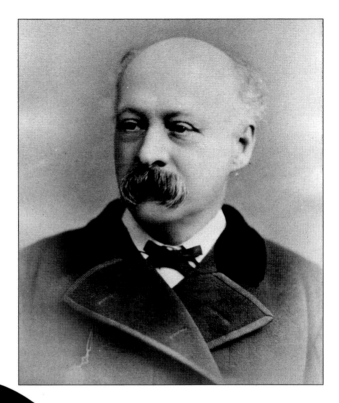

The park proposal also received the approval of the state legislature, and Gov. Henry Haight (seen here in an unofficial portrait) appointed the city's first Parks Commission. As soon as the Parks Commission was in existence, the Outside Lands Commission laid out a plan for private developers to turn the area into the Haight-Ashbury District.

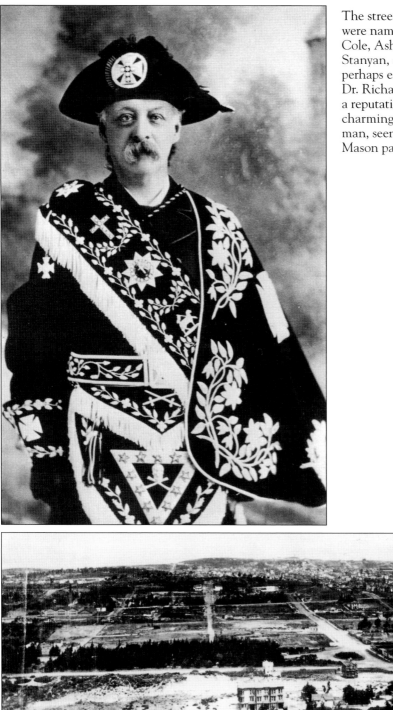

The streets of the development were named for supervisors Cole, Ashbury, Shrader, Stanyan, and others, an honor perhaps especially relished by Dr. Richard Cole, who had a reputation as a handsome, charming, flamboyant man, seen here in his Mason paraphernalia.

Buena Vista Hill provides panoramic views. In this photograph taken in the 1880s, some of the first buildings along Haight Street are visible in the foreground. Just beyond are Oak Street and the Golden Gate Park Panhandle.

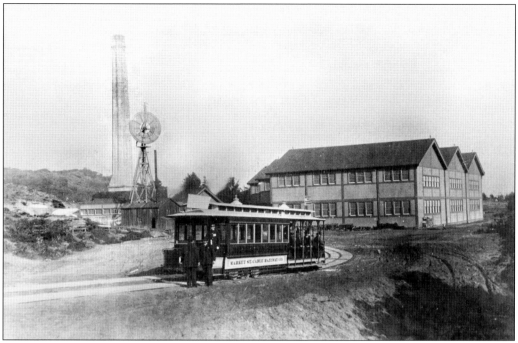

The arrival of the Market Street Railway's Haight Street line in 1883 began the evolution from dairy farm to neighborhood. Sadly Farmer Lange's dog, Shep, was fatally hit by one of the first cable cars to serve the Haight.

This railway engine house stood on the site of what would later become Kezar Stadium. Kezar has been home to two NFL teams and has hosted concerts by the Grateful Dead, the Doobie Brothers, and many other rock legends. Kezar was the second stadium at the southeast corner of Golden Gate Park. The California League's Haight Street Grounds stood between Stanyan and Shrader Streets and Waller and Frederick Streets. The opening game was played on April 3, 1887. After the league was discontinued in 1893, the stadium was demolished, and houses were built on the site.

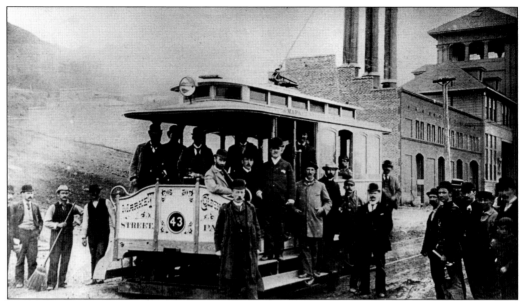

This early streetcar on the No. 43 line is a far cry from the electric coaches that run on the No. 43 bus line today.

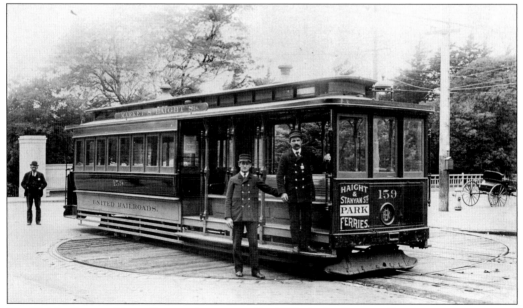

The Haight Street cable car line was inaugurated in 1883. At the Stanyan Street, or main, entrance to Golden Gate Park was a cable car turnaround. Gripmen, such as the men in the foreground, not only worked the cable grip but also manually turned the cars around at the end of the line.

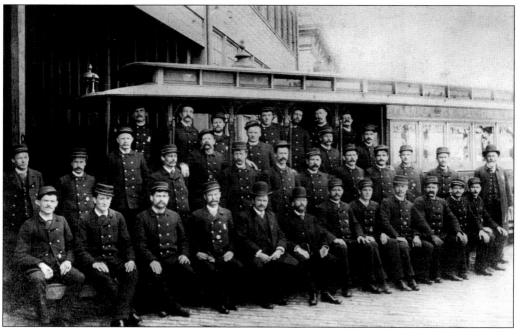

The gripmen, operators of the mechanisms that release the cable to bring the car to a stop and grip the cable to resume progress, pose outside the carbarn at Haight and Stanyan Streets.

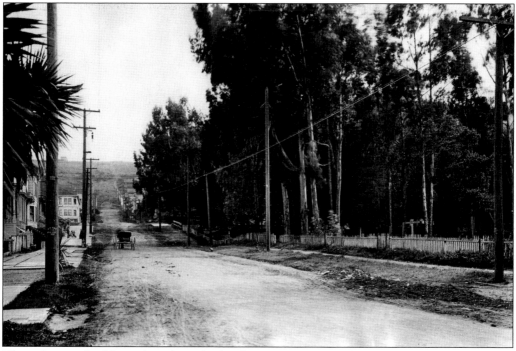

The railway and cable car lines brought development. However, this early view southward along Stanyan Street at the corner of Rivoli Street was more like a snapshot from a rural town in western Marin County than a San Francisco street scene.

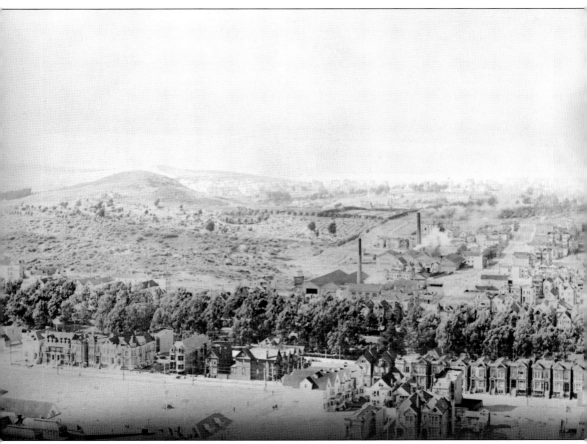

More buildings went up along Haight Street, and weekend houses were being built near the park by San Francisco's prominent families. Within the first decade of growth following the coming of the Haight Street railway, the Haight-Ashbury District was struck by catastrophe. In 1892, a devastating fire destroyed over a block of buildings in the area of Lyon and Page Streets and cost two firefighters their lives.

This is the earliest known photograph of the building at the northwest corner of Haight and Ashbury Streets, built in 1903 by Richard P. Doolan and lifted to insert storefronts in 1907. Note the brackets under the eaves, a distinctive feature of Victorian buildings. The building retains its Colonial Revival grandeur, though the brackets are gone (as is the dome on the building on the southeast corner). The family in the photograph is the Westerfields. Pauline Westerfield, wife of William, holds in her arms her granddaughter Vera. Vera's sister Erma (left) clowns around while sister Walla (right) looks on. They are standing outside what is now Haight Street Market. (Courtesy of Norman Larson via Juanita Bensen.)

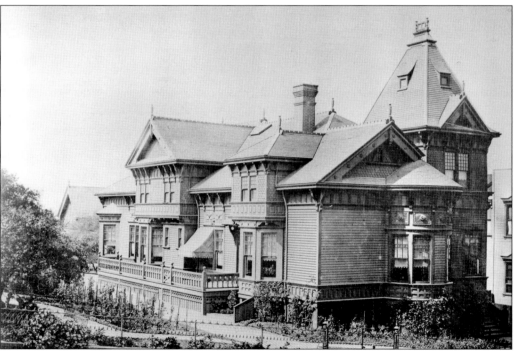

Here is an example of an early home on Ashbury Street. Note typical architectural features such as the mansard roof and bay windows.

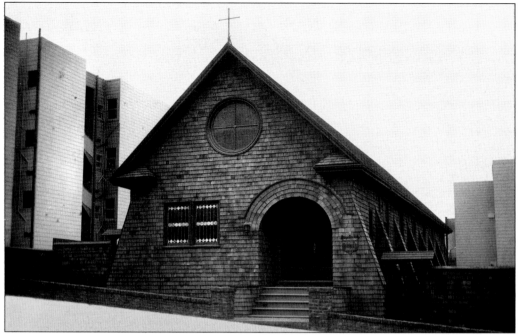

In 1900, a small group of Haight-Ashburians who had built grand houses in the neighborhood began meeting in a little building on Oak Street. In 1903, that group became a mission of St. Luke's Episcopal Church, and All Saints Episcopal Church became a full parish in 1905. All Saints was antedated by St. Agnes Roman Catholic Church, which was founded in 1893. This is the All Saints Church building at its original site, on the west side of Masonic Avenue between Haight and Waller Streets. The clamor of noisy streetcars was the catalyst for the building's move around the corner in 1905 to its current location on Waller Street. (Courtesy of All Saints Episcopal Church.)

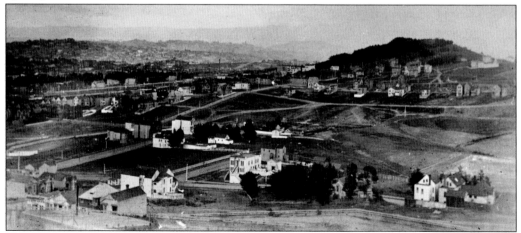

In this photograph dated 1895, taken from just west of Lange's farm, buildings line Haight Street, and new homes fringe Buena Vista Hill. The hill, which rises 569 feet above sea level, became Buena Vista Park, a distinctive feature of the neighborhood. On a sunny day in 2003, the Buena Vista Neighborhood Association and descendants of native Ohlones held a gathering atop the hill at which neighbors, including children, enjoyed Ohlone stories and songs and some Ohlone wisdom about native plants.

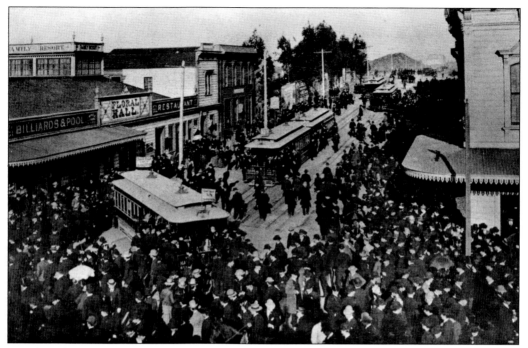

Many car lines converged on Haight Street and had their termini at Stanyan Street. Crowds traveled to the area near Golden Gate Park to enjoy diversions for all ages.

An anonymous poem written at the time of the opening of Golden Gate Park serves as an introduction to "San Francisco values." Though some of the wording might be jarring to a 21st-century ear, this poem's description of Golden Gate Park as a sort of "Kingdom of God" on Earth is still apt. (Courtesy of the *Haight-Ashbury Beat*.)

Here no line of caste or
color may be drawn;

 Welcome, sun-brown
Italiano.

And the swarthy Africano

 With is hair as short as
grass upon the lawn.

 Whether black or brown or
yellow,

 You are welcome,
little fellow!

 No policeman here to eye
you as you pass,

 Or to chase you with a
club

 If you breathe upon a
shrub,

 Or abuse that ancient sign:
"Keep of the grass."

 **Anonymous, 1888
 on the new Golden Gate Park**

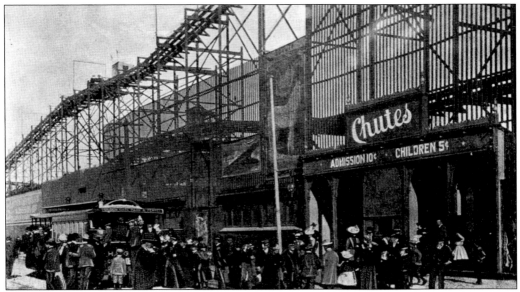

When the trains and cable cars brought crowds to Golden Gate Park, amusement businesses flourished. The Baird family, who at one time owned most of the land from Masonic Avenue to Shrader Street and from Page to Waller Streets, opened an amusement park on Haight Street between Cole and Shrader Streets. On November 2, 1895, a Chutes amusement park opened with a 350-foot shoot-the-chutes and a refreshment stand and soon expanded to include a roller coaster, carousel, shooting gallery, penny arcade, and a 3,000-seat theater to showcase vaudevillian acts.

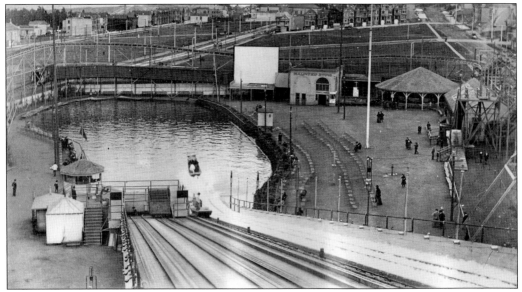

In addition to a refreshment stand, the Chutes operated the Chutes Café, which served only non-alcoholic refreshments with the intention of providing an oasis for women and children. When interviewed for the *Haight-Ashbury Newspaper* in the 1980s, Katherine Sutter, who was born at 1334 Masonic Avenue in 1895, recalled being taken to the Chutes as a child: "I remember shooting down the slide and my hand-embroidered hat, the pride of my life, blew into the water. I was heartbroken."

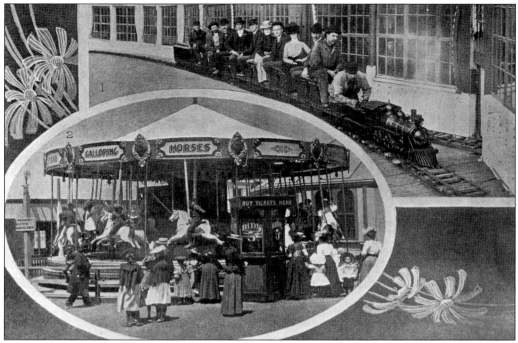

This promotional postcard features the Scenic Railway roller coaster and the Galloping Horses carousel.

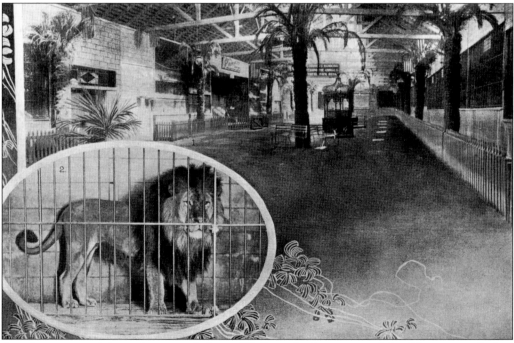

Another postcard from this period shows Wallace the lion, part of the Chutes zoo. In her interview, Katherine Sutter recalled feelings that may have been shared by other children in the neighborhood: "I was scared of the lions at the Chutes 'cause they'd roar at night. I thought they'd get out of their cages and wander over to my bedroom."

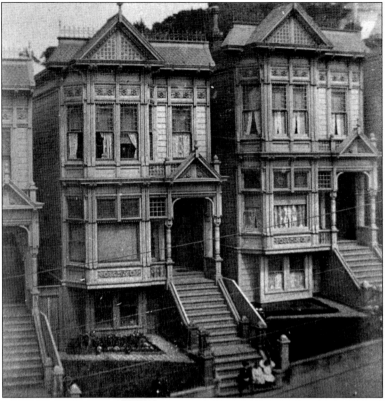

Here is the home on Masonic Avenue where Katherine Sutter was born in 1895. In the background, the tree line of Buena Vista Hill rises to the east.

These Italianate Victorian homes, including 1334 Masonic Avenue, are still single-family homes.

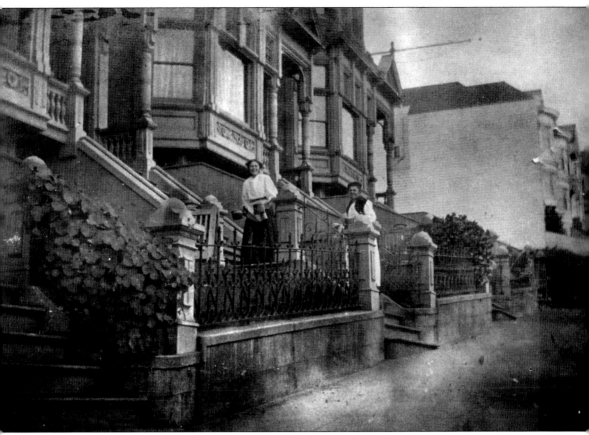

Women smile at the camera outside 1334 and 1336 Masonic Avenue. The 1300 block of Masonic has the long-held tradition of an annual block party, and nasturtiums still decorate front gardens, as in the foreground above.

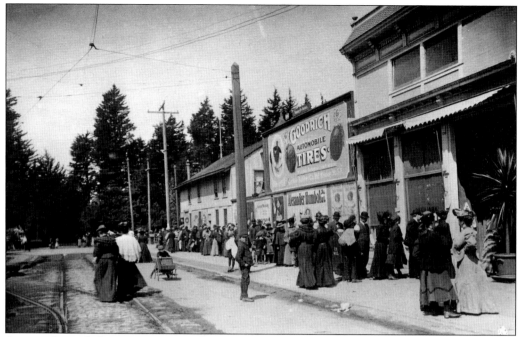

Among the early businesses on Haight Street was a tire shop near Stanyan Street. The eastern end of Golden Gate Park can be seen at the end of Haight Street.

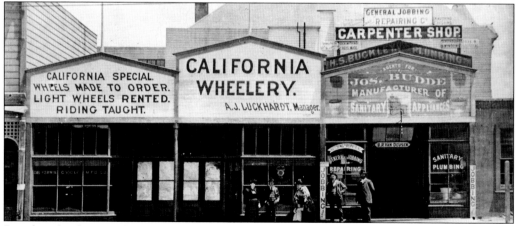

Bicycles, plumbing, and carpentry remain important interests in the Haight, as they were in these shops on Haight Street near the Stanyan Street entrance to the park.

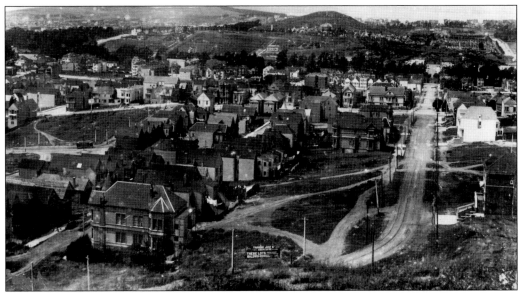

This view from Ashbury Heights shows the neighborhood's early development. The billboard advertises lots for sale by Adolph Sutro, in association with Baldwin and Howell, to be shown June 5. A newspaper advertisement from the same period made the claim "once you see this beautiful land, you'll never want to live anywhere else," a prediction that has proved accurate for the many longtime families of Ashbury Heights.

A produce market, a woman pushing a stroller with a little girl (center), a well-dressed lady pushing a baby stroller (near the gate across the street), and ornate bay windows are still common sites in the Haight. The sign on the trap behind the horse reads, "UP TO DATE MKT. 101 CARL ST AT COLE, PHONE PARK 356." By 1905, this former dairy farm had become a popular destination for leisure activities and an attractive place to build a home.

Here a couple smiles broadly as they pose on Frederick Street. The houses in the background on the southeastern side of Masonic Avenue are still there, and the onion-domed turret still keeps watch over the intersection. Stucco apartment buildings built in the mid-20th century now sit on the southeast and southwest corners across Frederick Street.

Perhaps this little girl with the hula hoops would bring an even broader smile to the faces of that long-ago couple.

Two

REFUGE AND HOME

By the spring of 1906, the Haight-Ashbury District, its desirability enhanced by its proximity to Golden Gate Park, had become a place where young and old, the wealthy and those of moderate means, single people and families with children came for recreation and for a change of venue from the grittier life in the northeastern part of the city.

Unforeseen events were about to transform the Haight into a neighborhood that attracted San Franciscans for its tranquil stability. The earthquake of April 18, 1906, and the subsequent conflagration devastated the densely populated areas east of Van Ness Avenue. Over 15,000 people were displaced from their homes.

The effects on the Haight-Ashbury District were profound but quite different from other parts of the city. The Haight experienced very little damage from the disaster and became both a temporary refuge and a permanent community for San Franciscans seeking a safer place to make a home. No longer just a fashionable location for second homes, the Haight became a flourishing neighborhood.

By 1910, most of the land in the area had been developed into residences. By 1920, the neighborhood had its own library branch, and in the following decade, the Dudley Stone and Grattan grammar schools were built to accommodate the neighborhood children.

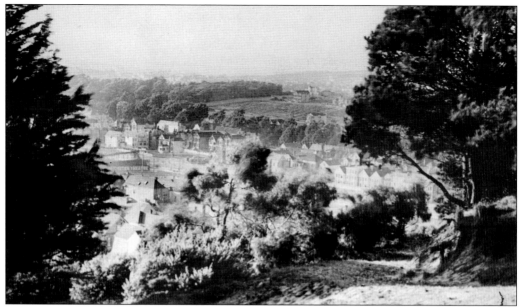

As the neighborhood grew, the view northwest from Buena Vista began to look like a thriving village, with clusters of houses on the hillsides, in the valleys, and more buildings along Haight Street, the trees of Golden Gate Park and its Panhandle marking the northern edge of the neighborhood. The 1906 earthquake and conflagration would alter the neighborhood but in ways that one might not assume.

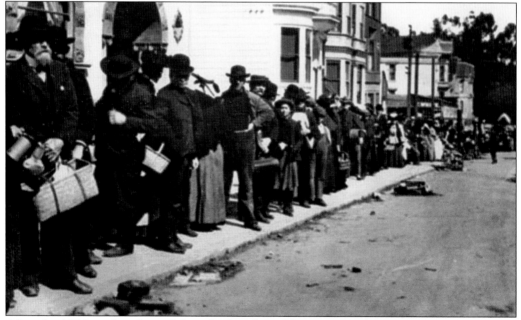

After the 1906 earthquake and fire, the Haight-Ashbury District became a refuge and haven for many San Franciscans. The neighborhood had sustained little damage from the earthquake and was far enough from the fire line between Van Ness Avenue and Franklin Street to emerge unscathed. People from throughout the city and from all walks of life stood in bread lines like this one near Golden Gate Park.

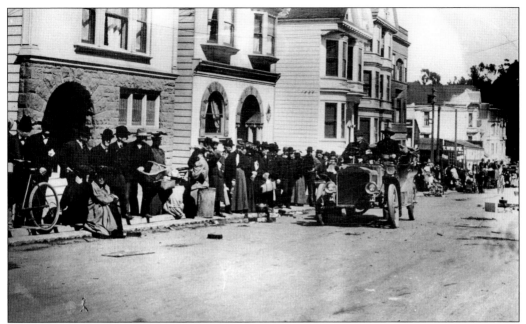

Aid workers included agents of the American Red Cross, seen here in the driver's seat of an early automobile.

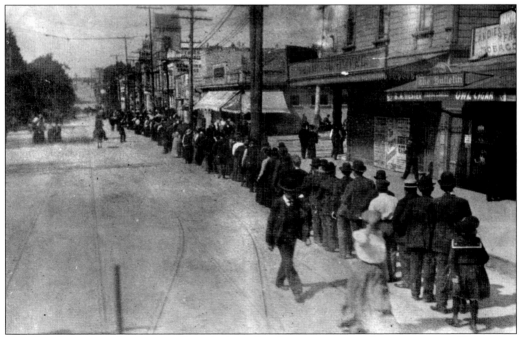

Usually a destination for patrons of bicycle shops, hotels, restaurants, and amusement establishments, Stanyan Street became the site of bread lines that stretched for many blocks.

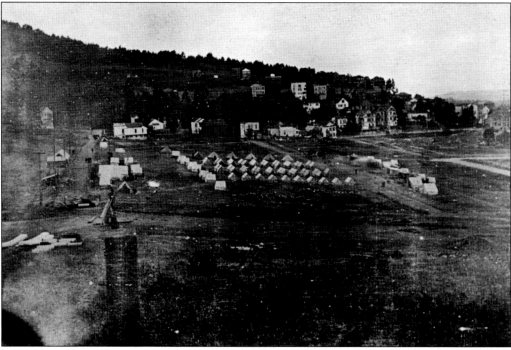

In addition to Red Cross workers, the national guard was deployed, setting up a tent camp at the southwestern edge of the neighborhood, the onetime site of William Lange's dairy farm.

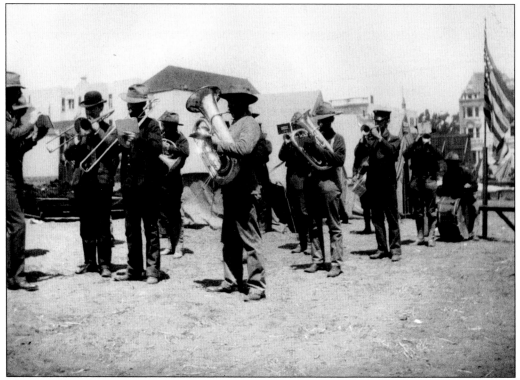

The guard band maintained morale and raised spirits as the city recovered from the disaster.

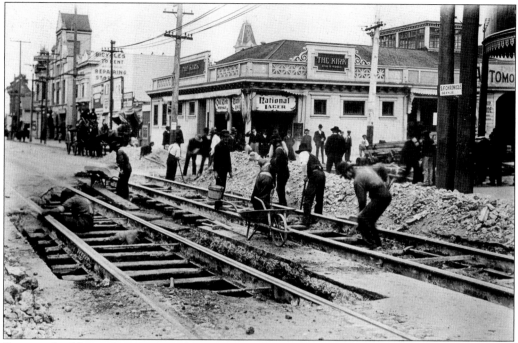

Destroyed cable car lines were replaced with electric streetcar tracks after the earthquake. Here work is done on Stanyan Street near Haight Street. The new Hotel Kirk stands at the northwest corner at 1898 Haight Street.

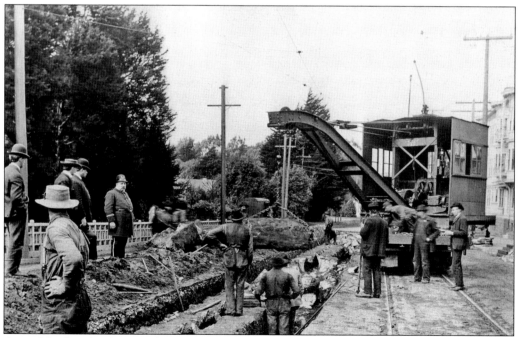

A neighborhood policeman keeps an eye on the track work.

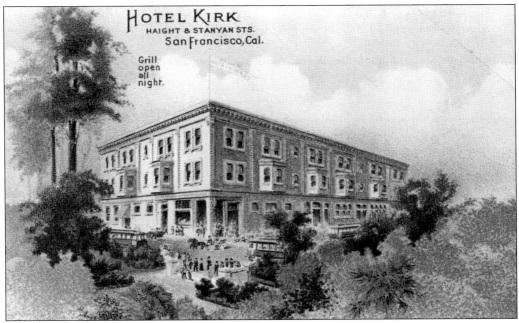

San Francisco gracefully reemerged after the disaster of 1906. An artist's rendering on a picture postcard of the refurbished Hotel Kirk's exterior depicts the transit terminus, an idyllic park-side location, and after-hours dining as components of an attractive destination.

The actual Hotel Kirk was popular, if not quite as impressive as it appeared on the promotional postcard. City records show that the hotel operated at Stanyan and Haight Streets until 1916.

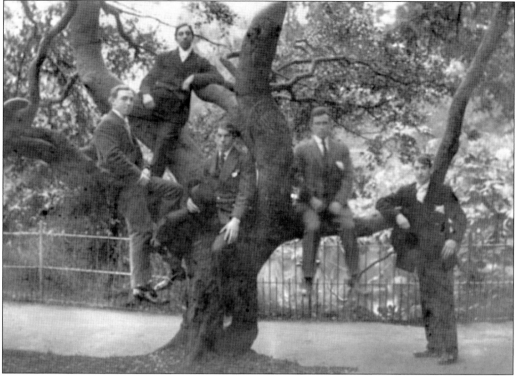

This photograph was taken in April 1908, two years after the earthquake. At Alvord Lake in Golden Gate Park, across Stanyan Street from the Hotel Kirk, these five men portray the confidence of a city rebounding from one of the greatest catastrophes in history. (Courtesy of the San Francisco Public Library.)

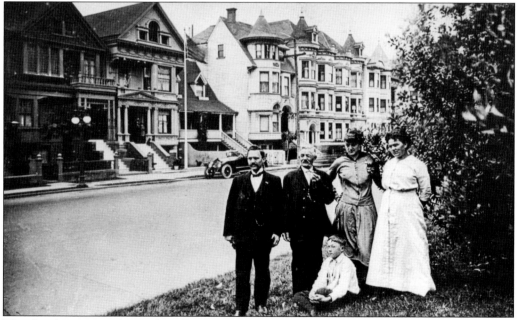

This family poses in the Panhandle across from 1864–1866 Fell Street in 1914.

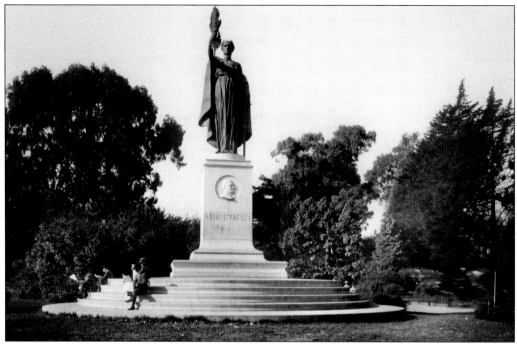

Residents enjoyed the Panhandle and public monuments, such as this 1903 tribute to William McKinley, the 25th president of the United States, who was assassinated in 1901. To this day, people relax and read on the steps of this monument. In a 1986 interview for the *Haight-Ashbury Newspaper*, Katherine Sutter, who was born at 1334 Masonic Avenue in the year 1895, recalled seeing Pres. Theodore Roosevelt at the dedication of the monument. "We were too busy playing to be impressed," she remembered.

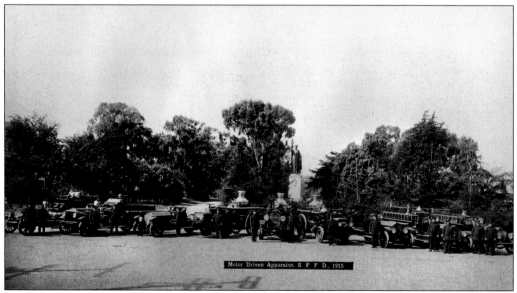

The San Francisco Fire Department (SFFD) became legendary after the events of April 1906. Here firefighters pose with "motor driven apparatus" in 1915 at the eastern end of the Panhandle in front of the McKinley monument.

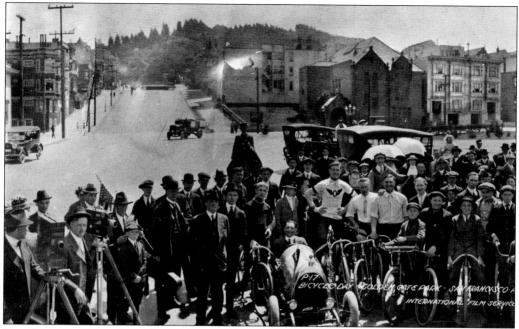

Bicycling was, and still is, a favorite activity in and around Golden Gate Park. This "Bicycle Day" was held on April 19, 1916.

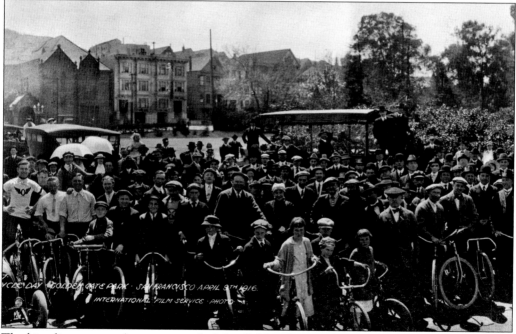

The bicyclists pose at the eastern end of the Golden Gate Park Panhandle.

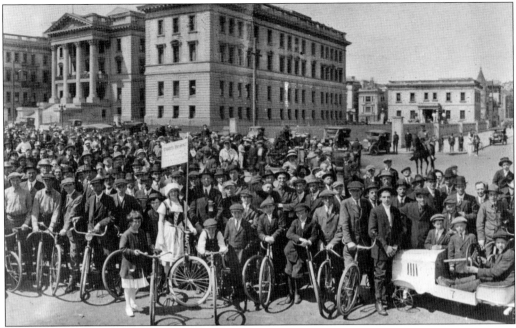

Here the presence of a young woman in costume bearing a sign that reads "Dutch Brand" suggests that Bicycle Day might have been a precursor to the corporate-sponsored "Bay to Breakers" 12K foot race, whose route takes runners past this very spot near Fell and Baker Streets.

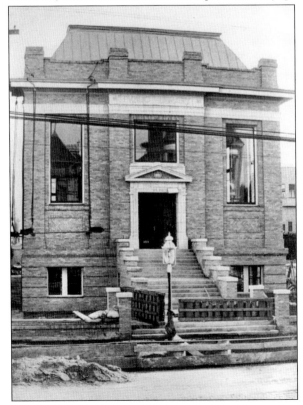

The Park branch of the San Francisco Public Library opened in 1916. This same building still serves the community. Adults read and study at the long tables, with regulars exchanging hushed greetings. Children and their adult companions enjoy the ample children's section. Classes, book clubs, and poetry readings are usually on the schedule, and in the community room downstairs, there are Chinese lion dancing exhibitions at the Lunar New Year, regular neighborhood association meetings, and a myriad of other events and activities.

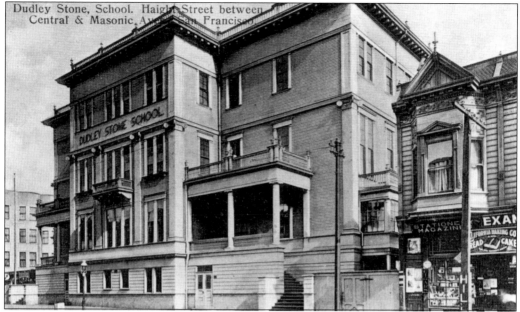

The Dudley Stone School was later renamed the William R. D'Avila School in honor of an esteemed principal. The school was closed at the end of the 2003–2004 school year, and the building on Haight Street, between Masonic and Central Avenues, currently houses an extension of City College.

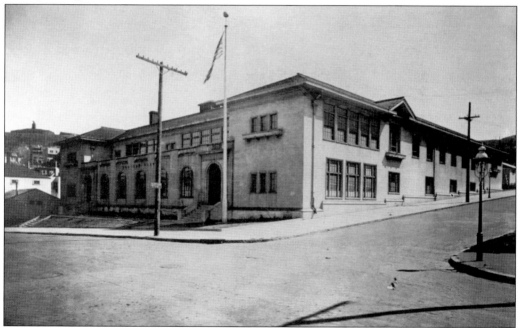

In 1919, the original Grattan School building stood where a late-20th century, earthquake-retrofitted building now stands. In the background, note the Triumph of Light statue atop the monument at the summit of Mount Olympus. The statue, a gift to the city from Adolph Sutro, is gone now. Its disrepair was noted by a historian in 1954, and it was later removed, though the pedestal remains. Trees now keep the top of Mount Olympus, the geographical center of the city, tucked away.

In this present-day photograph, the top of Mount Olympus is covered by trees. The late-20th-century Grattan School building is nestled behind trees and a garden maintained by the students. The school building includes an inner courtyard, and the children still play in the large schoolyard.

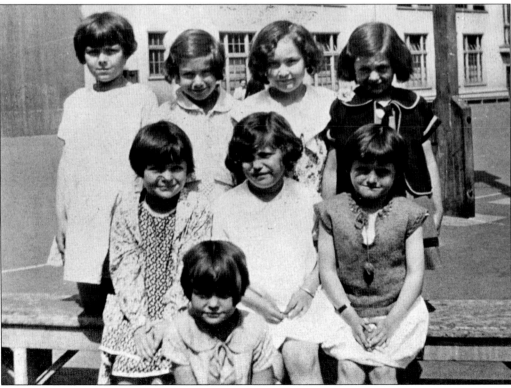

These schoolgirls pose in the Grattan schoolyard in the 1920s.

This 1925 promotional photograph, which speaks volumes for Rickenbacker automobile brakes, was taken at the top of Stanyan Street. The upper blocks of Stanyan Street were some of the last in the neighborhood to be paved because they are some of the steepest.

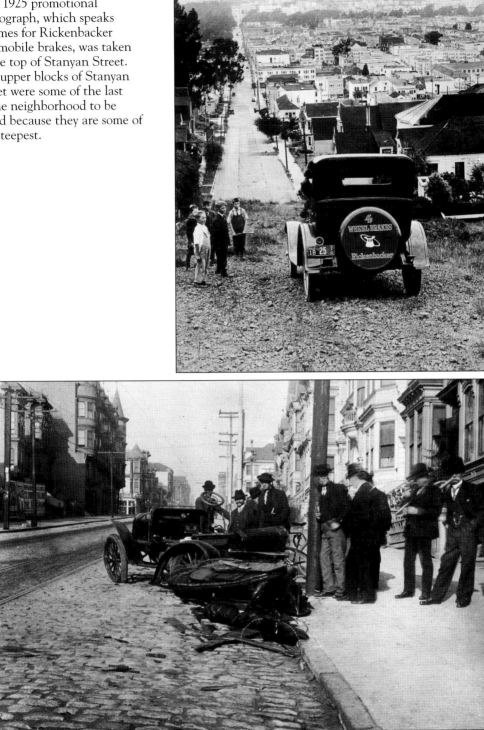

This unfortunate incident leads one to wonder whether either automobile had Rickenbacker brakes.

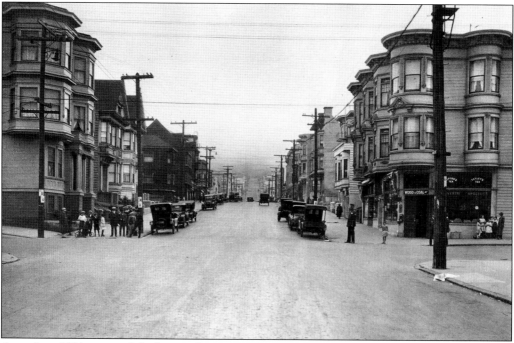

As early as 1924, automobiles began claiming parking spots along the neighborhood streets. This view on Cole Street shows the familiar fog nestled over the tops of the hills to the south.

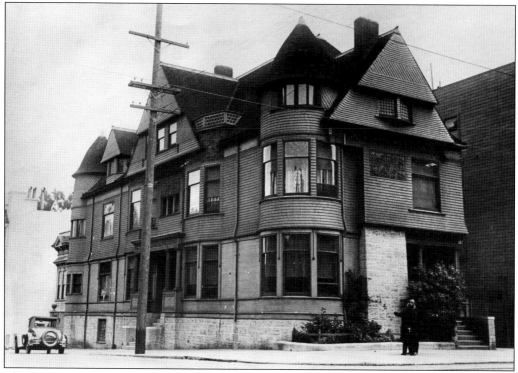

This home is an outstanding example of the architecture favored by prosperous San Franciscans making their homes in the Haight-Ashbury District.

Growing up in the Haight still involves sidewalk wagon rides, as it did for these children at Grattan and Belvedere Streets in the 1920s.

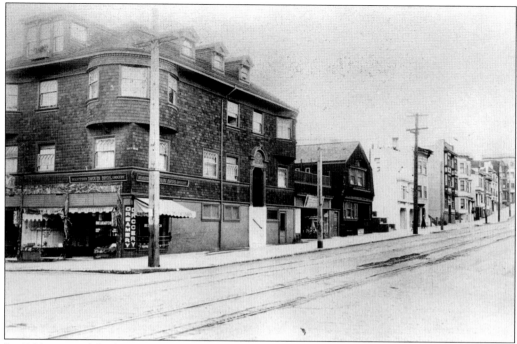

In 1920, none of the houses along the north side of Carl Street, east of Cole Street, had yet been cleared to make way for the Sunset Tunnel. The three buildings in the foreground stand today housing a launderette, a hamburger restaurant, and a private home in what was once a Hare Krishna house. The buildings just beyond were razed in the construction of the streetcar tunnel and its accompanying park.

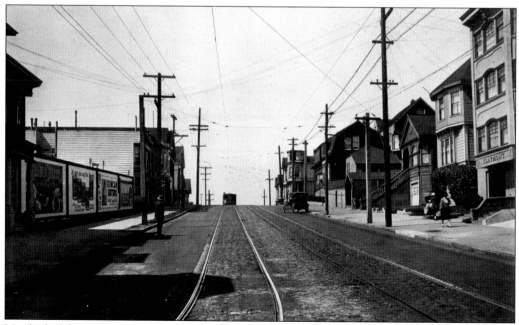

Up the hill, houses along the west side of Clayton Street, south of Frederick Street, were removed in the tunnel and park construction.

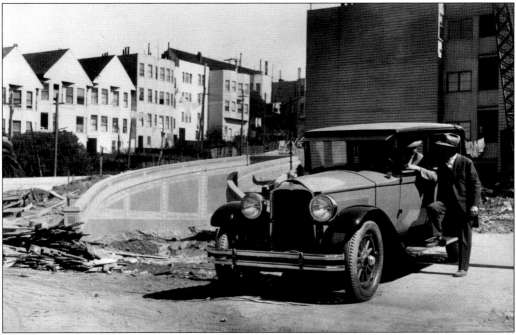

The Sunset Tunnel allows streetcars to cut through Buena Vista Hill, creating a direct route from the central part of the city to the Sunset District.

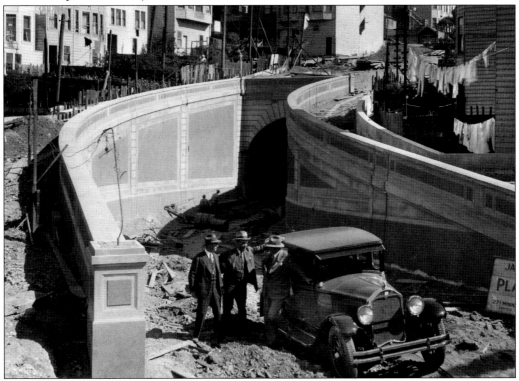

Here the construction is almost finished. Still, it would be quite a while before the adjacent park would be planted with the grass, calla lilies, and cedars that are there today.

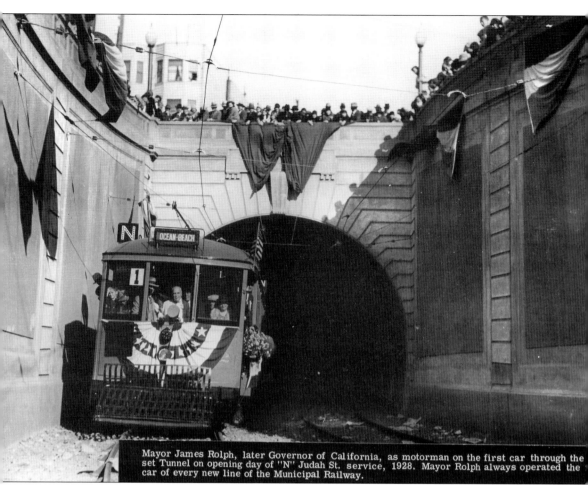

Mayor James Rolph, later Governor of California, as motorman on the first car through the set Tunnel on opening day of "N" Judah St. service, 1928. Mayor Rolph always operated the car of every new line of the Municipal Railway.

James "Sunny Jim" Rolph, who served as mayor of San Francisco from 1912 until 1931, acted as motorman on the first car of every new municipal railway line, as he did on the North Judah Street line on opening day of the Sunset Tunnel in 1928. This photograph captures the general sense of well-being and optimism that prevailed in San Francisco at the time. The coming economic disaster would negatively impact the Haight far more than the natural disaster of 1906.

Three

HARD TIMES, REFUGE, AND, ALWAYS, HOME

On the eve of the Great Depression, the Haight-Ashbury District was a well-established neighborhood. San Francisco had recovered gloriously from the 1906 devastation, and Mayor Sunny Jim Rolph, future governor of the state of California, enjoyed great popularity among a generally contented citizenry.

The stock market crash of October 1929 began an economic depression that had a deep impact on the financially successful inhabitants of the Haight-Ashbury District. During World War II, many of the houses in the Haight were converted into apartments as thousands of workers came to San Francisco to toil in the shipyards and other industries related to the cause of victory.

The Haight had once offered serenity to San Franciscans after a devastating earthquake and fire. In the post-war era, the neighborhood was once again a haven. Now it offered safety and a sense of well-being to black families who sought refuge from the racism in some other parts of the country. Those San Franciscans who did not move to the suburbs experienced the inclusive atmosphere that became a cornerstone of the Haight-Ashbury neighborhood.

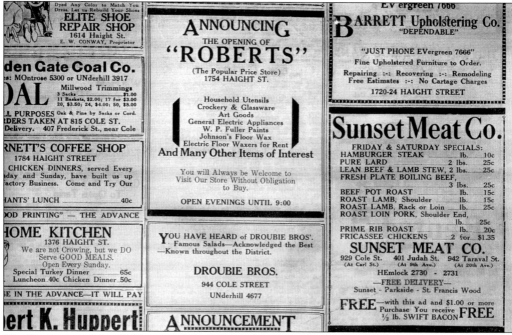

The front page of this 1931 issue of the *Ashbury Heights Advance* heralded the opening of Roberts Hardware, which is still owned and operated by members of the Roberts family. Note too the advertisement for Elite Shoe Repair, which is also still a busy cobbler's shop.

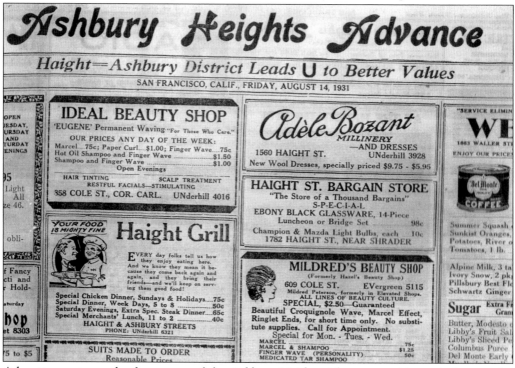

Advertisements on the front page of the *Ashbury Heights Advance* provide a window on the fashions and prices in Depression-era Haight-Ashbury.

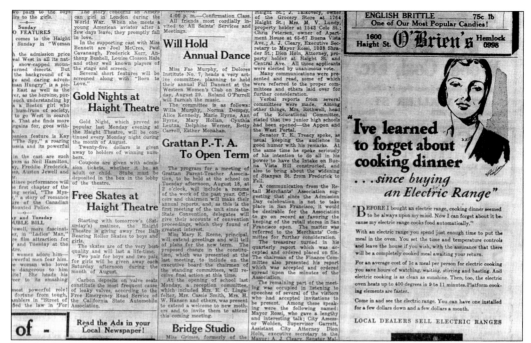

Inside the *Advance* are articles about special events at the Haight Theater and an item on the Grattan School PTA. Referring only to mothers, this item sheds light on the changes in families in the past 70 years; fathers, mothers, and other guardians are involved in today's Grattan PTA, including same-sex couples.

An advertisement for an available four-bedroom apartment cites a monthly rent of $45, contrasting with an average of $4,000 or more per month in 2008.

The Golden Gate Park Panhandle and the towers of St. Ignatius Roman Catholic Church serve as the backdrop for this display of contrasting modes of transportation.

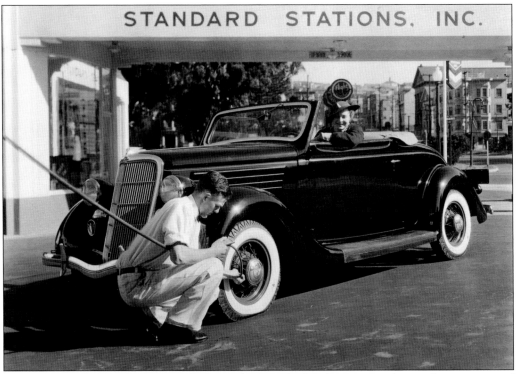

This photograph, dated July 1, 1935, shows the Standard Oil station at the northeast corner of Fell Street and Masonic Avenue, when gas was about 17¢ a gallon. Today Chevron customers pay around $4 a gallon at this site.

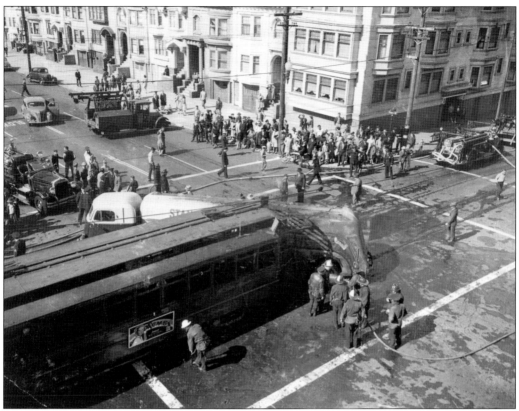

This collision between a streetcar and a Standard Oil truck was kept from becoming a catastrophe. Once again, the SFFD lived up to their reputation.

The stables on the south side of Haight Street, near Stanyan Street, attracted equestrian enthusiasts from throughout the area.

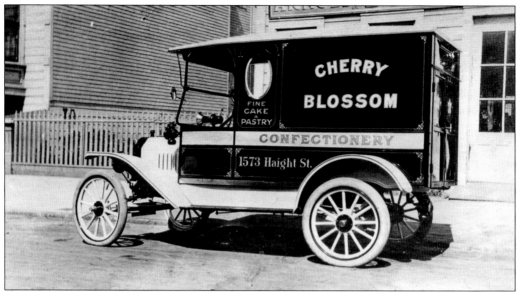

The Cherry Blossom Bakery boasted a spiffy delivery truck.

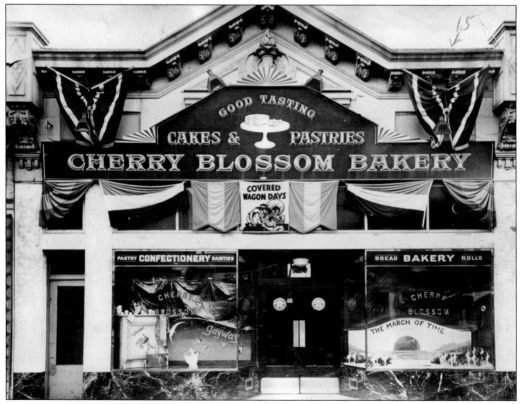

Here is the Cherry Blossom Bakery at 1573 Haight Street decked out for Covered Wagon Days in 1939.

The involvement of the United States in World War II, beginning in 1941, meant that many war industry workers sought housing in San Francisco. Some of the residences in the Haight-Ashbury District became apartment buildings. Workers lived alongside the longtime families of the Haight. This soldier poses on Lyon Street.

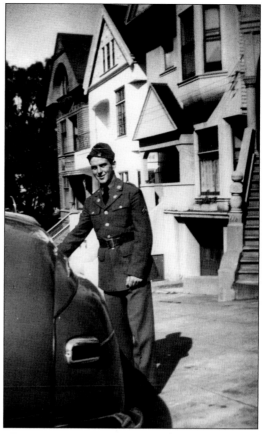

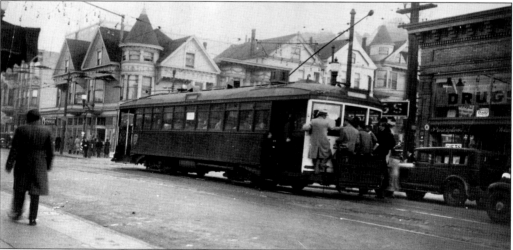

Men catch a ride on a crowded streetcar heading east on Haight Street as it crosses Masonic Avenue. The buildings look the same today, and the coaches still make their way downtown, though they've been updated a couple of times. People still wear fashionable coats and jackets on cool days and when the fog is so thick that it obscures Buena Vista from view, as in this photograph. Some things have changed: the drugstore is now a dress shop, and it's perfectly normal to see women on public transportation too!

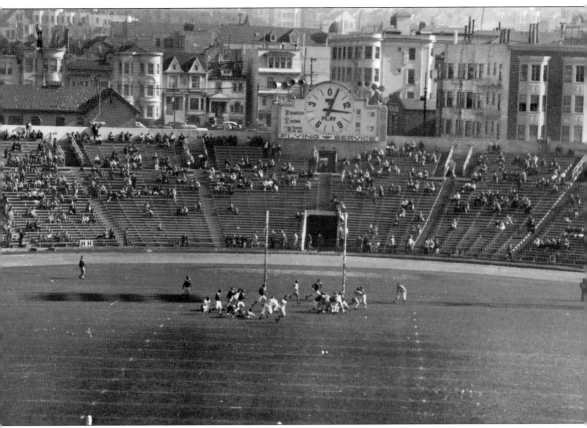

Kezar Stadium, at the southeast corner of Golden Gate Park, opened in May 1925. It was built with funds donated by Mary Kezar in honor of her family members, who were San Francisco pioneers. The stadium was home to many schools' sport organizations, including that of Polytechnic High School, which was located across Frederick Street. This photograph shows a football game between Polytechnic and Balboa High Schools. The stadium has also been home to the Oakland Raiders and San Francisco 49ers NFL teams. In the 1970s, Kezar was the site for concerts by the Grateful Dead, Joan Baez, San Franciscan Carlos Santana, the Doobie Brothers, and many others. Polytechnic High School, educating since 1895, was closed by the city in 1972. Kezar Stadium was demolished in 1989 and rebuilt. It is now a venue for sporting events, including children's sport programs, and it is a favorite place for neighbors to walk, run, and play soccer.

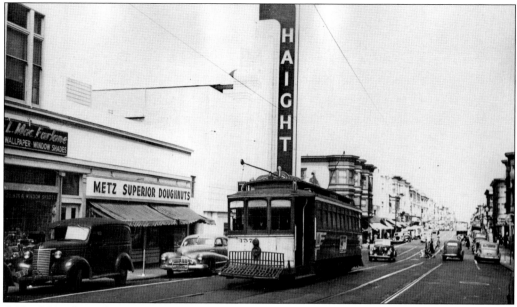

A No. 7 Haight and Ocean line streetcar heads west past the Metz doughnut shop and the Haight Theater in the 1700 block of Haight Street in 1948.

The Haight Theater opened around 1910 and hosted vaudevillian acts, then movies. Here the marquee advertises, among other features, the 1941 Oscar-nominated *Topper Returns*, starring Joan Blondell, Roland Young, Carole Landis, and Billie Burke. When the theater closed as a cinema in 1964, the hippie community renamed it the Straight Theater, and it became a center for performances and other events.

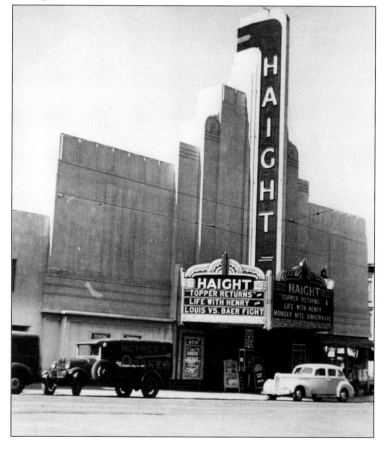

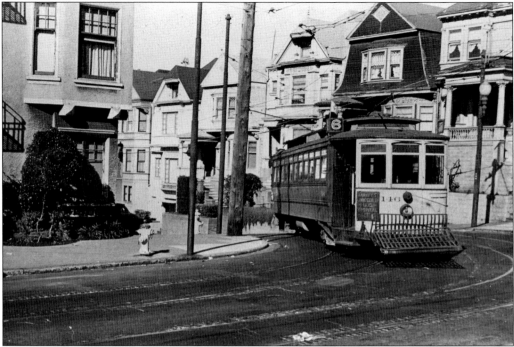

The No. 6 Haight and Masonic streetcar line began service June 10, 1906, as the United Railroads Hayes and Masonic line, terminating at Third and Parnassus Avenues. Its route changed on February 7, 1916, when it began running from the ferries to Ninth Avenue and Pacheco Street via Market Street, Haight Street, Masonic Avenue, Frederick Street, Clayton Street, Carl Street, Stanyan Street, Judah Street, and Ninth Avenue.

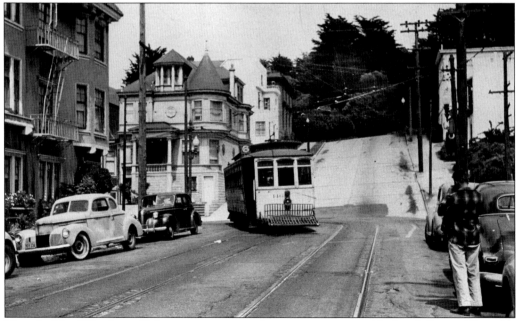

Here the No. 6 Haight and Masonic streetcar makes its turn west onto Frederick Street. The trees of Buena Vista can be seen in the background.

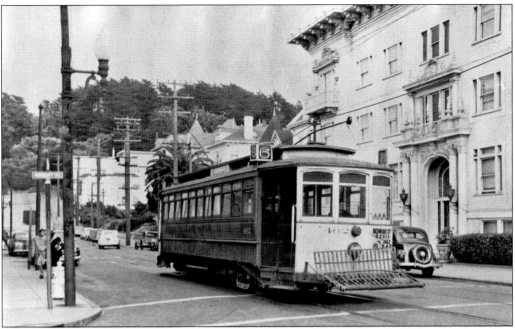

At Frederick and Ashbury Streets, the No. 6 passes the Crossways building.

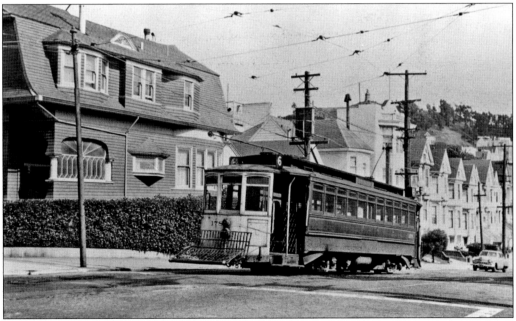

Here the No. 6 prepares to turn right onto Frederick Street from Clayton Street. Like nearly all of the buildings in this part of the run, all of the houses in this photograph are seen by No. 6 passengers today.

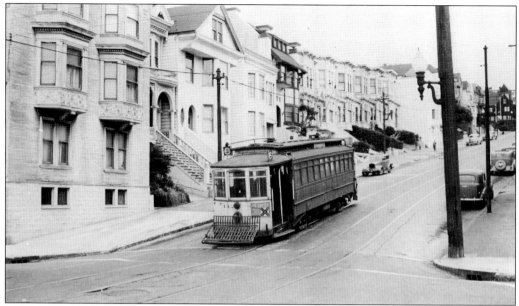

The No. 6 Haight and Masonic streetcar later became the No. 6 Parnassus MUNI bus line, one of the most reliable lines in the city. It has been a vital link to downtown for generations of workers, shoppers, pregnant women, children, elderly people, the infirm, and anyone else needing to make it up the long hill from Haight to Frederick Streets. Here is the No. 6 coming down Masonic Street on its debut run.

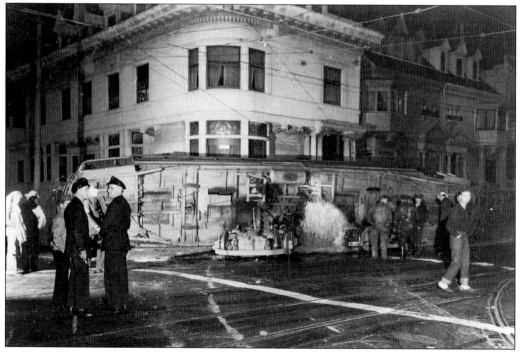

In the 1950s, the city's services effectively supported the Haight-Ashbury District. Soon though, as the Haight became home to nonconformists, the relationship between some residents and some city employees became strained.

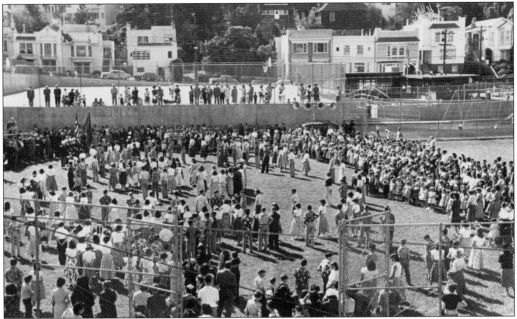

A sunny day brings 1950s Haight residents to Grattan Park for a community event. The park still attracts soccer players to the field, children to the playground, and families and neighbors to the Grattan School's annual outdoor film night.

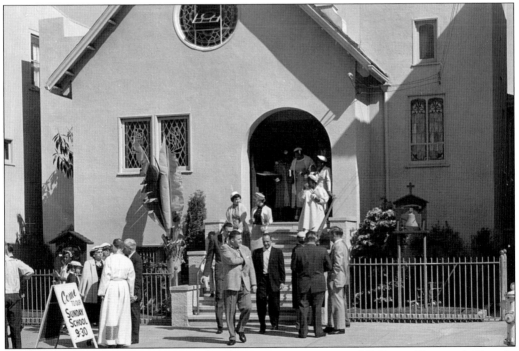

Parishioners and clergy chat after a Sunday morning service at All Saints Epsicopal Church. After its 1905 move from Masonic Avenue to Waller Street, the church building was given a new stucco facade, a feature shared by many buildings in the city. The shingle siding was restored later in the 20th century. (Courtesy of All Saints Episcopal Church.)

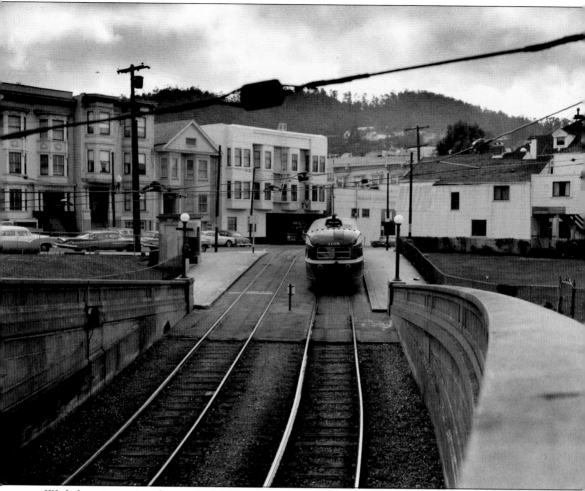

With housing prices lowered, the Haight-Ashbury District was saved from much of the more unsightly modernization of the mid-20th century. Inexpensive apartments and unfashionable Victorian and Edwardian architecture attracted beatniks in the 1950s, and students began moving into the neighborhood as well. The coach and streetcar lines, including the North Judah Street line, photographed here in 1962, made most of the city accessible, including the San Francisco State campus at the extreme southwestern edge of the city. The Haight once again reflected, and magnified, the nation's transition into a new era.

Four

A SPECTACLE OF LOVE

In the 1950s, beatniks and students began moving into apartments, while many families remained, not participating in the mid-century flight to the suburbs. In the 1960s, a nonconformist movement transformed Haight Street, and the reverberations were felt around the world.

One woman has fond memories of growing up in Ashbury Heights. She attended Notre Dame de Victoires, then a school for girls, on the north side of the city and, after school, played with the kids on her block of Masonic Avenue. As the 1960s progressed, she recalls, the scene walking to St. Agnes Church down the hill and across Haight Street became a bit surreal. Her family would be dressed for mass, complete with white gloves for her mother and the girls, contrasting with the less conventionally attired young adults they saw along the way.

On Belvedere Street, many children enjoyed the freedom of being watched over by their multi-generational African American families. One man who grew up on Belvedere recalls that, when children of nonconformists began attending Grattan, some of the teachers made disparaging comments about the boys' long hair. He also has a memory of going down to Haight Street to "the best candy store in the world" and encountering a police raid. One officer grabbed the little boy by the collar and told him to get along home. He did.

In 1966, when brothers Ron and Jay Thelin opened the Psychedelic Shop, Haight Street became the center of a movement in which LSD and other hallucinogens were catalysts for creativity, augmented by the acid rock scene. The Grateful Dead, Janis Joplin, and other innovative musicians lived in the neighborhood. Young people came to the Haight from across the country, indeed from around the world, to be at the center of a movement that became worldwide. In the Haight-Ashbury District, the Diggers—a radical improvisational acting group later renamed the Free City Collective—initiated free meals, street theater, and sometimes-aggressive acts of rebellion. The *Oracle* paper was founded by Allen Cohen and others. The young Dr. David E. Smith established the Haight-Ashbury Free Clinics. At first, the Haight was again a refuge. Then, as critical mass was reached, the neighborhood was deeply effected.

In the early 1960s, the MacCauley Gate was still the main entrance to Golden Gate Park. The cable car turnaround was gone, though, as MUNI bus lines replaced the cable cars and streetcars.

This article from the *San Francisco Chronicle*, dated September 6, 1965, focuses on the Haight as an alternative to North Beach, where beatniks had made their homes in the 1950s.

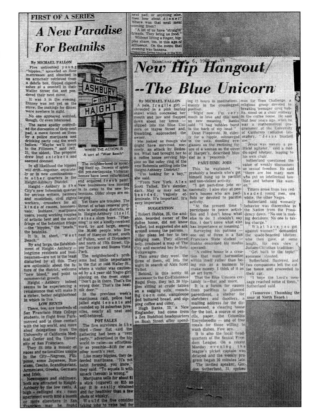

After the opening of the Psychedelic Shop on January 3, 1966, at 1535 Haight Street, the face of Haight Street began to change. Shops like In Gear (1580 Haight Street), which carried mod clothing; Wild Colors (1418 Haight Street), purveyors of locally produced crafts; Mnasidika boutique (1510 Haight Street), a Greek name meaning "in remembrance of justice" and the Spartan addressed in one of the poet Sappho's homoerotic verses; and the I and Thou coffee shop (1736 Haight Street) appeared. The Haight Independent Purveyors (HIP) organization had some differences with the Haight-Ashbury Merchants Association as traditional concepts of commerce clashed with progressive ideas. Even HIP was challenged by Peter Coyote, born Peter Cohon, and the Diggers. Two founding members of HIP live in the same house they did in the 1960s. Their shop on lower Haight Street is a treasure box of handmade items from around the world, as well as memorabilia from the 1960s. (Courtesy of the San Francisco Public Library.)

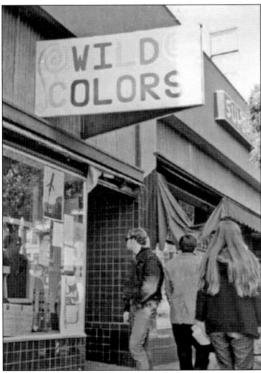

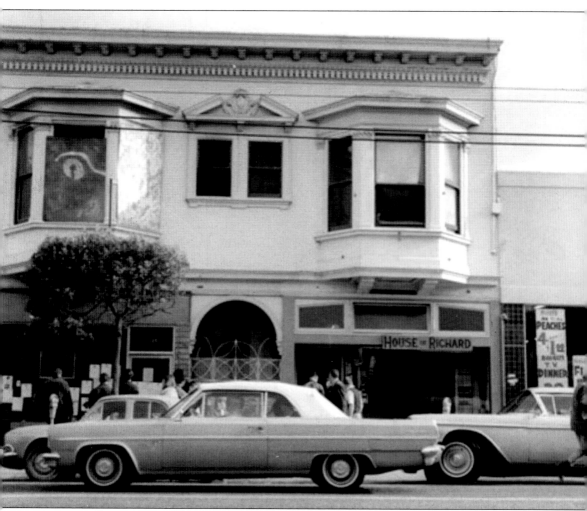

The House of Richard boutique at 1541 Haight Street stood next to the market. The sign advertises peaches at four for a dollar.

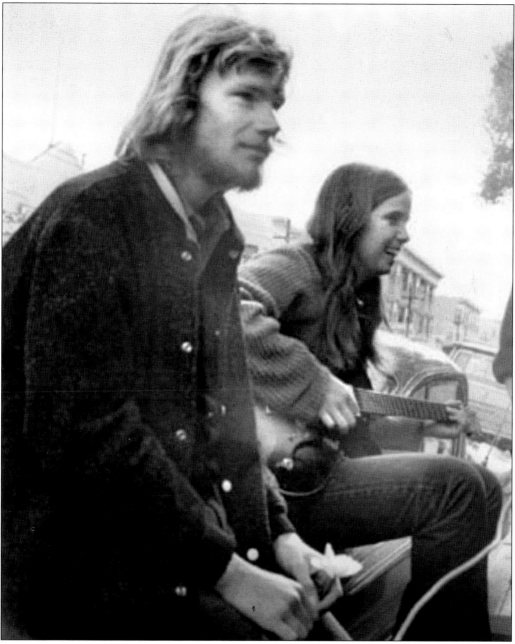

For a while, the Haight-Ashbury District was the site of serene, happy recreation, as it had been in the years just after the 1906 earthquake. (Courtesy of the San Francisco Public Library.)

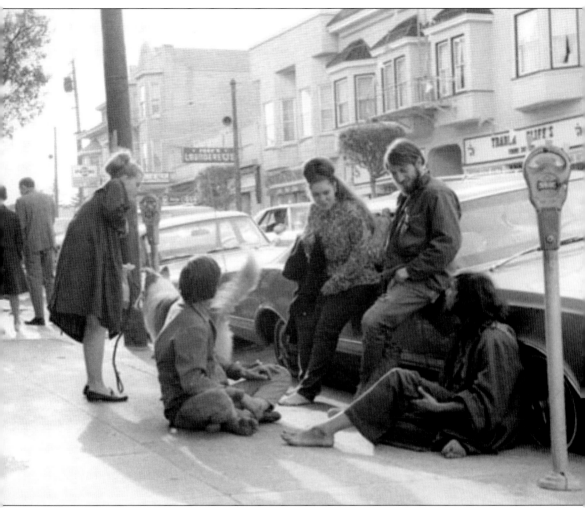

Bouffant meets hippie hair on Haight Street. The woman at left (with dog) wears a mainstream coat, loafers, and somewhat elaborate hairstyle, in contrast to the bare feet and shaggy hair of the hippie movement. The woman leaning against the car seems to be bridging a gap between the casual jeans and her 1950s-influenced hairdo. Note, too, the mainstream garb of the woman and man in the background. Haight Street was at the forefront of changing times, reflected in contrasting styles.

Dead Like Live Thunder

By Ralph J. Gleason

SAN FRANCISCO has become the Liverpool of America in recent months, a giant pool of talent for the new music world of rock.

The number of recording company executives casing the scene at the Fillmore and the Avalon is equalled only by the number of anthropologists and sociologists studying the Haight-Ashbury hippy culture.

Nowhere else in the country has a whole community of rock music developed to the degree it has here.

At dances at the Fillmore and the Avalon and the other, more occasional affairs, thousands upon thousands of people support several dozen rock 'n roll bands that play all over the area for dancing e a c h week. Nothing like it has occurred since the heyday of Glenn Miller, Benny Goodman and Tommy Dorsey. It is a new dancing age.

The local band with the greatest underground reputation (now that the Jefferson Airplane has gone national via two LPs and several single records) is a group of young minstrels with the vivid n a m e, The Grateful Dead.

A Celebration

Their lead guitar player, a former folk musician from Palo Alto named Jerry Garcia, (see This World's corner) and their organist, harmonica player and blues singer, Pig Pen (Ron McKernan) have been pictured in national magazines and TV documentaries. Richard Goldstein in the Village Voice has referred to the band as the most exciting group in the Bay Area and comments, "Together, the Grateful Dead sound like live thunder."

Tomorrow The Grateful

"THE GRATEFUL DEAD'S" PIG PEN

Dead celebrate the release of their first album, on the Warner Brothers label. It's called simply "The Grateful Dead" and the group is throwing a record promotion party for press and radio at Fugazi Hall.

The Dead's album release comes on the same day as their first single release, two s i d e s from the album — "Golden Road" and "Cream Puff War."

The Dead, as their fans call them, got their exotic name when guitarist Garcia, a learned and highly articulate man, was browsing through a dictionary. "It just p o p p e d out at me. The phrase — 'The Grateful Dead.' We were looking for a name at the time and I knew that was it."

The Grateful Dead later discovered the n a m e was from an Egyptian prayer:

"We g r a t e f u l dead praise you, Osiris . . ."

Garcia, who is a self-taught guitarist ("my first instrument was an electrical guitar; then I went into folk music and played a flat top guitar, a regular guitar. But Chuck Berry was my influence!"), is at a loss to describe the band's music, despite his expressiveness.

The Grateful Dead draws from at least five idioms, Garcia said, including Negro blues, country & western, popular music, even classical. (Phil Lesh, the bass player, is a composer who has spent several years working with serial and electronic music.)

"He doesn't play bass like anybody else; he doesn't listen to other bass players, he listens to his head," Garcia said.

Pig Pen, the blues vocalist, "has a style that is the sum of several styles," Garcia pointed out, including that of country blues singers such as Lightnin' Hopkins, as well as the more m o d e r n, urban blues men.

"When we give him a song to sing, it doesn't sound like someone else, it comes out Pig Pen's way." Pig Pen's father, by the way, is Phil McKernan, who for years had the rhythm & blues show on KRE, the predecessor of KPAT in Berkeley.

Bill Sommers, the drummer, is a former jazz and rhythm & blues drummer. "He worked at the same music store I did in Palo Alto; I was teaching guitar and he was teaching drums," Garcia said. He is especially good at laying rhythms under a solo line played by the gui-

tars. Bob Weir, the rhythm guitarist, "doesn't play that much straight rhythm," Garcia said, "he thinks up all those lovely-pretty things to do."

The Dead (they were originally the W a r l o c k s) have been playing t o g e t h e r for over two years now. They spend at least five or six hours a day rehearsing or playing or "just foolin' around," Garcia continued.

"We're working with dynamics now. We've spent two years with loud, and we've spent six months with deafening! I think that we're moving out of our loud stage. We've learned, after these past two years, that what's really important is that the music be groovy, and if it's groovy enough and it's well played enough, it doesn't have to be too loud."

Dance Band

The Dead's material comes from all the strains in American music. "We'll take an idea and develop it; we're interested in form. We still feel that our function is as a dance band and that's what we like to do; we like to play for dancers. We're trying to do new things, of course, but no arrange our material to death. I'd say we've stolen freely from everywhere, and we have no qualms about mixing our idioms. You might hear some traditional style classical counterpoint cropping up in the middle of some r o w d y thing, you know!"

The eclectic electric music has won the Dead its Warner Brothers contract, offers of work in films, a dedicated group of fans who follow them f a i t h f u l l y and the prospect of national tours, engagements in New York and elsewhere. But Garcia, who is universally loved by the rock musicians and fans, is characteristically calm about it all. "I'm just a student guitar player," he concluded, "I'm trying to get better and learn how to play. We're all novices."

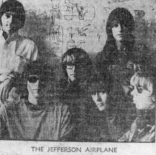

THE JEFFERSON AIRPLANE

This World, Sunday, March 19, 1967

This article from Sunday, March 19, 1967, hails the extraordinary rock scene in San Francisco. Pictured are the Grateful Dead's Ron "Pigpen" McKernan and Jefferson Airplane. The Grateful Dead was founded by Jerry Garcia, who grew up in San Francisco's Mission District. The group made music that incorporated traditional American songs and original compositions by Garcia, Robert Hunter, and others. In the early days, the Dead frequently performed free shows. One fine day in 1967, they put two flatbeds together outside the theater on Haight Street and gave an impromptu concert. A very happy audience filled the street and sidewalks from Cole Street all the way to Masonic Avenue for what witnesses remember as a three- to four-hour show. An ethic of sharing and giving and generally expansive thinking, informed by LSD and other psychedelics, remained at the core of the band's subculture. Perhaps Garcia's most enduring philosophy is, "Think for yourself," which also encapsulates much of the hippie movement.

As a parish, St. Agnes Roman Catholic Church continued to serve the community's increasingly varied needs. Families attended mass, the Boy Scout troop met, and ministries expanded into areas of assistance for those in need on the street. (Courtesy of St. Agnes Church.)

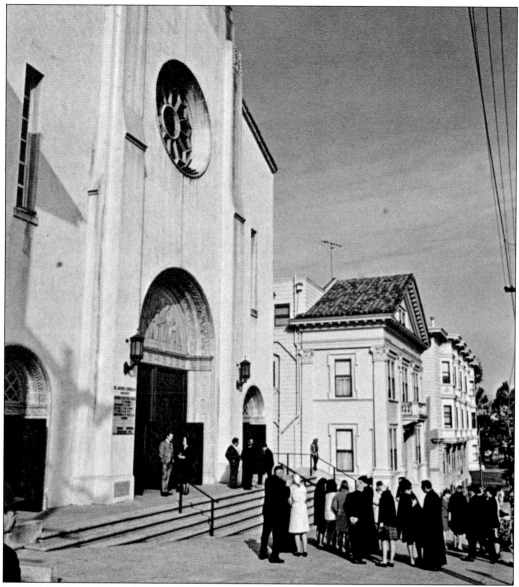

In 1967, St. Agnes Church was about to celebrate its 75th anniversary. Here worshipers linger after mass, and eucalyptus trees grace the Golden Gate Park Panhandle half a block away. (Courtesy of St. Agnes Church.)

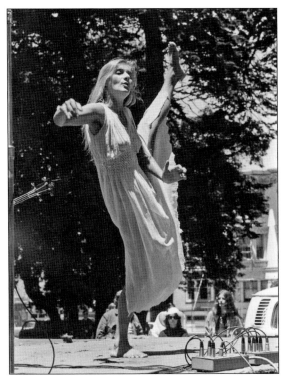

A half-block away from St. Agnes Church in the Panhandle, another celebration takes place. Music and dance were common components of events in the Haight in 1967.

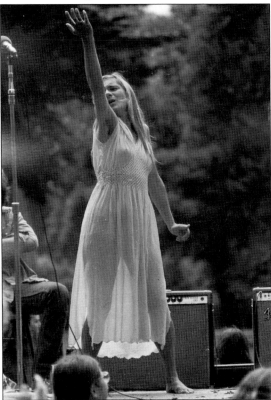

Published simultaneously in Canada
by Little, Brown & Company (Canada) Limited

PRINTED IN THE UNITED STATES OF AMERICA

☮

*This book is affectionately dedicated to
the entire Haight-Ashbury community*

Steven Sept 24, 1983

Our Dreams continue,
this is the Part of
my life spent in Nam
Who knows if it
Weren't for Nam you
May have been read
about me in this Book
HEE HEE!
 Love,
 PEACE
Continued Hippie ne.
"Doc"

During this time period, many young people were, of course, in the armed forces in Vietnam. From this inscription in a book about figures in the Haight at the time, it appears that at least one had his heart elsewhere. (Photograph by the author.)

71

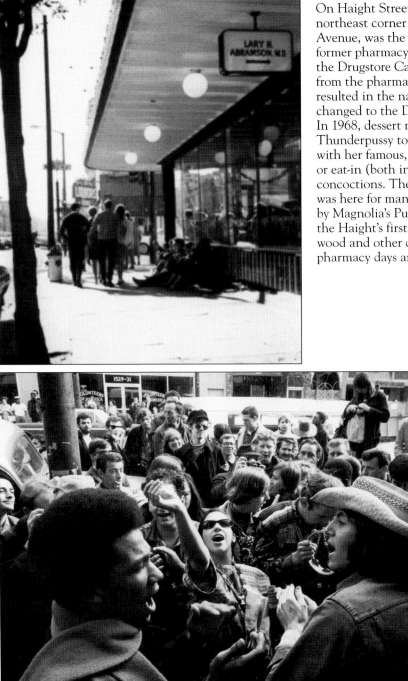

On Haight Street, near the northeast corner of Masonic Avenue, was the front of a former pharmacy reopened as the Drugstore Café. Objections from the pharmacists' board resulted in the name being changed to the Drogstore Café. In 1968, dessert maven Magnolia Thunderpussy took over the place with her famous, home-delivered or eat-in (both into the wee hours) concoctions. The restaurant Dish was here for many years, followed by Magnolia's Pub and Restaurant, the Haight's first brewery. The dark wood and other details from the pharmacy days are still in place.

Crowds flocked to the neighborhood to gawk at the growing crowds of young nonconformists. Tourists snapped photographs of residents, who would in turn snap photographs of the tourists behind the windows of their motor coaches. One tour bus company ran a "hippie town" tour, prompting this protest in the spring of 1967. As these demonstrators sang their protestations, 30 of their peers were arrested. (Courtesy of the San Francisco Public Library.)

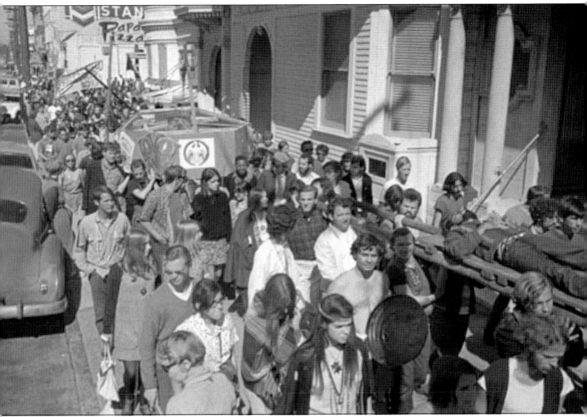

On October 6, 1967, the Diggers, named after a 17th-century English communal activist group, staged a hippie funeral, declaring an end to the media-generated hype surrounding the movement. People were discouraged from continuing to congregate in the Haight-Ashbury District and encouraged instead to carry the ideals of social reform and brotherly love to the far corners of the earth.

The illuminating effects of psychedelics were not the only drug experiences. For some, bad trips and addiction were part as well, and David E. Smith (center), a young physician, opened the Haight-Ashbury Free Clinics in 1968. Dr. Smith has become world-renowned as an expert on addiction medicine and psychoactive drugs. The clinics continue to address the needs of those who require medical care.

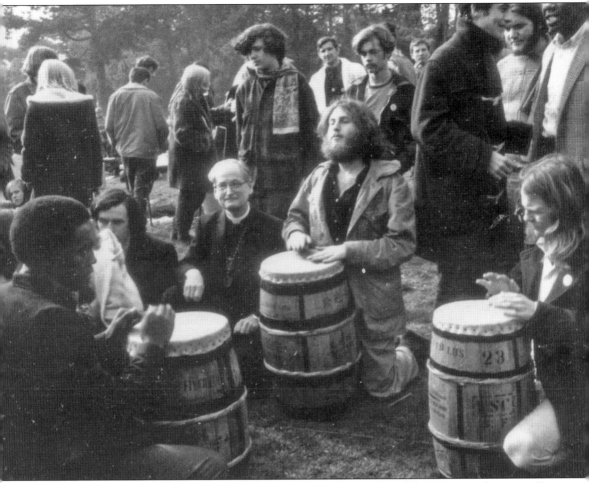

Not all of the young people who came to the Haight in the 1960s left. Drum circles are still an almost daily occurrence at Hippie Hill, not far from the Stanyan Street entrance to Golden Gate Park. This image of the Reverend Leon Harris, rector of All Saints Episcopal Church on Waller Street, tells an important part of the story of that era. Father Harris was rector of All Saints from 1949 until 1971. In many ways, he was a traditionalist, and All Saints became an Anglo-Catholic Episcopal church with his arrival. Then, when masses of young people began to come to the neighborhood, Father Harris took the difficult step of calling on his congregation to reach out with him to minister to the needs of the hippies, offering food, clothing, and sanctuary. Father Harris also provided a safe space for flower children to gather on Saturday nights, when police raids were often executed. Amplified Ohm, a music group of the time, often facilitated those evenings. For a time, All Saints even housed an office of the Diggers group. Leon Harris is still remembered with admiration and affection by flower children, many now grandparents, who made a permanent home in the neighborhood; by Episcopalians, some of whom are former flower children; and by many other San Franciscans.

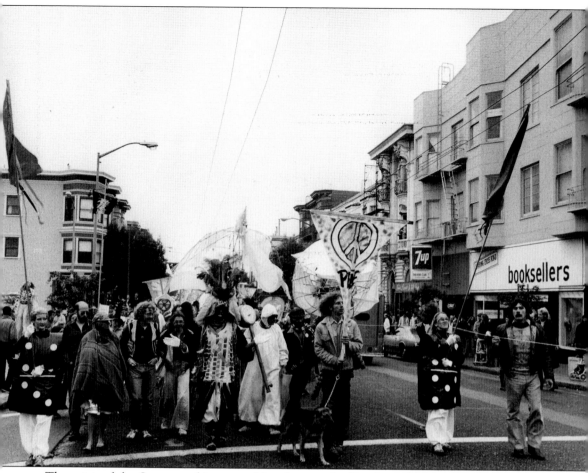

The spirit of the Summer of Love would endure in the Haight and beyond in peace marches, street theater, and generosity of spirit.

Five

HARD TIMES, AGAIN, AND HOMECOMING

After 1968, Haight Street was devastated. An influx of hard drugs and a lack of police presence made things difficult "down the hill." Some business, such as barbershops, candy stores, Elite Shoe Repair, and Robert's Hardware remained, but numerous storefronts were boarded up. Many flower children participated in the back-to-the-land movement up north to Marin and Sonoma Counties and beyond.

In 1978, those same pioneers, many with children, returned to the Haight-Ashbury District, and a rebirth began. Baby boomers were able to take advantage of low property values and purchase Victorian homes where some of them had once "crashed" in groups. The public transportation that had begun the creation of the neighborhood 80 years before, the stunning architecture, the graceful hills and inspiring views, and the central location made the Haight an ideal place put down roots. The neighborhood's recent history meant that most of the residents were open-minded people with a shared social conscience and a nonconformist bent.

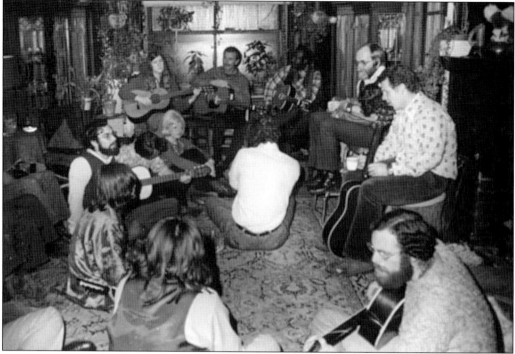

In 1948, a group of high schoolers lead by Dave Rothkop founded the San Francisco Folk Music Club. Herb Jager took the club to the level of promoting community events in 1959. In response to the cold war, the club's young people sought "mutual understanding through music." Since 1962, Faith Petric has led the club, which continues to hold Friday night jams like this one, photographed in 1974, at a home on Clayton Street. (Courtesy of the San Francisco Public Library.)

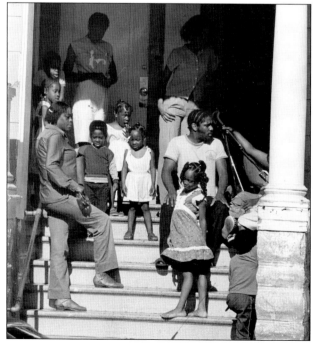

Haight-Ashburians gather for a portrait on a sunny day in the 1970s.

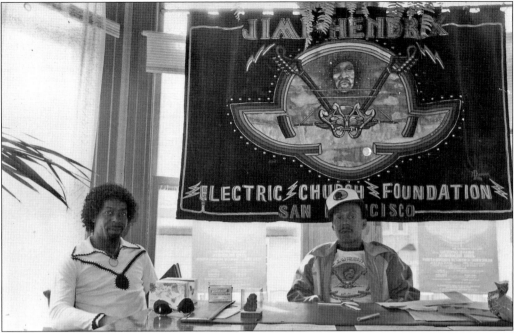

The Jimi Hendrix Electric Church Foundation raised an altar and a wax statue to honor the late guitarist and singer-songwriter, who had been a shining light of rock and roll until his death in September 1970 at the age of 27.

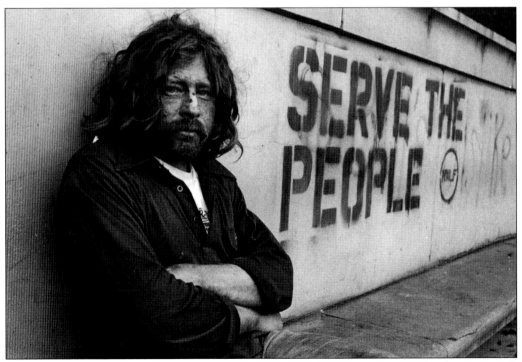

Some suffered greatly in the years when the Haight was lacking in services for those in need. This photograph was taken in 1975.

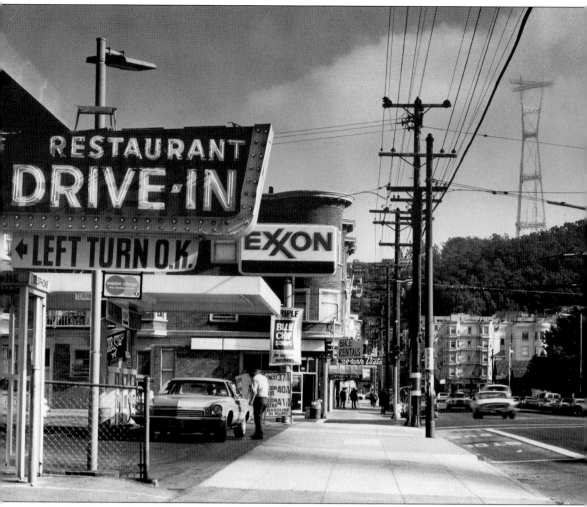

At the intersection of Stanyan and Haight Streets, looking south, a filling station is now at the former site of the Hotel Kirk.

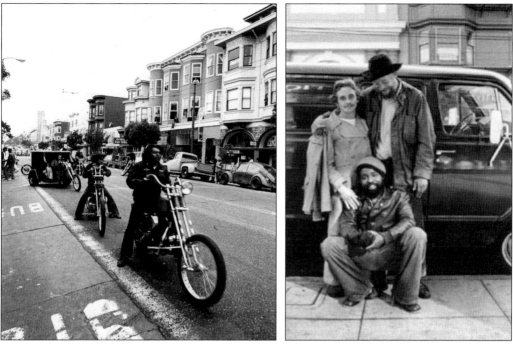

As seen here in 1976 (above left), Haight Street retained its renegade character. Above right, three buddies smile for the camera in 1977. (Above right, courtesy of the San Francisco Public Library.)

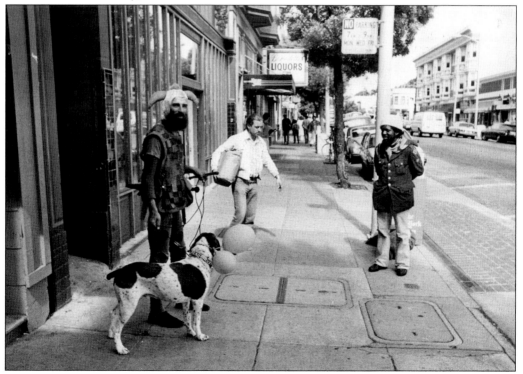

Sartorial imagination has been an enduring result of the Summer of Love.

In 1978, a group of people led by Paul "Pablo" Heising organized the first annual Haight Street Fair. The artist David Wills created the poster heralding the event. By many accounts, the first annual Haight Street Fair was a glorious homecoming. Many flower children who had taken part in the back-to-the-land movement returned to the neighborhood and met up with long-lost friends. The after party at the Shady Grove, now the Massawa Eritrean Restaurant at 1538 Haight Street, is remembered fondly by many. The fair heralded a rebirth for the Haight. (Courtesy of David Wills.)

The Park Station police officers have a colorful job that requires an easy temperament.

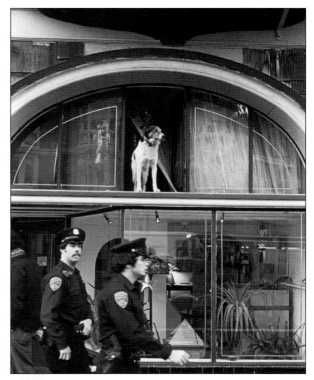

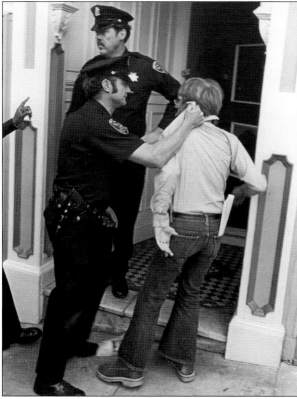

The relationship between Haight-Ashburians and the police has often been a complex one.

SUMMER OF LOVE

During the National Catholic Education Association Convention held in San Francisco in April 1968, a telegram was read to the delegates from the late Vice President of the United States, Hubert H. Humphrey, in which Mr. Humphrey urged Catholic school systems to utilize their personnel and to open up their facilities particularly during the summer for youth from disadvantaged, low income target areas across the land.

Since 1968 the Catholic Youth Organization (CYO) and the Department of Education of the Archidiocese of San Francisco have responded to this call!

The "Summer Of Love" (SOL) a non-profit, non-denominational comprehensive summer youth project was born!

25,000 youth ages 5-18 for the past ten (10) years have participated in a comprehensive summer program. The districts involved are the Mission, Hunter's Point, Bayview, Visitacion Valley, Haight-Ashbury, Bernal Heights, Noe Valley and Chinatown.

A well rounded educational cultural and recreation program is provided. Major areas of activities include math, reading, language, arts, typing, auto shop, photography, drama, dancing, silk screening, international dinners, basketball, tumbling, volleyball, tennis, swimming, gymnastics, field trips, summer olympics, movies and a walk-a-thon.

A special summer lunch program is sponsored by the State of California. A well balanced type A lunch is supplied to the youth at each site. Adults living within the community are hired to prepare and serve the meals.

Volunteers are an important aspect of the program and cannot be overlooked. Over 5,000 people from all walks of life have volunteered in this program. Volunteers come in all ages: teenagers, adults and senior citizens. Volunteers are utilized as teachers, field trip chaperones, nurses, monitors, teacher aides, tutors, recreation supervisors, secretaries and lunch personnel.

A valuable work-experience project funded by the Mayor's Office of Employment and Training and administered by the Catholic Youth Organization S.O.S. program has provided employment for over 2,500 youths!

SUMMER OF LOVE has supplied work-sites and supervision where youth are taught to work with others, accept responsibilities, and at the same time, develop a sense of their own self worth!

A positive alternative to boredom, vandalism, drugs and alcohol which young people experience when they have "nothing to do" is an important goal!

This article marks 10 years of the Catholic Youth Organization's (CYO) Summer of Love (SOL) program, which was started in 1968 in response to then-Vice Pres. Hubert Humphrey's call for Catholic facilities to serve disadvantaged youth, especially in the summers. (Courtesy of St. Agnes Church.)

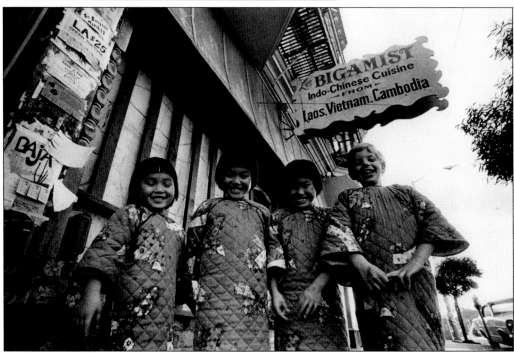

Children of the owner of Le Bigamist restaurant smile happily for the camera.

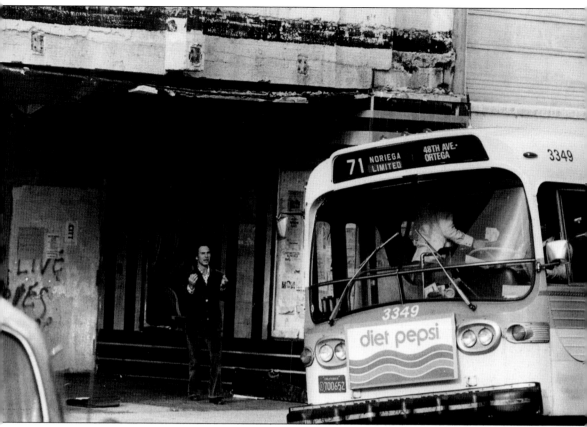

In 1964, the storied Haight Theater was closed. No longer a cinema, the Haight Theater was renamed the Straight Theater and, afterwards, functioned as a multi-purpose venue.

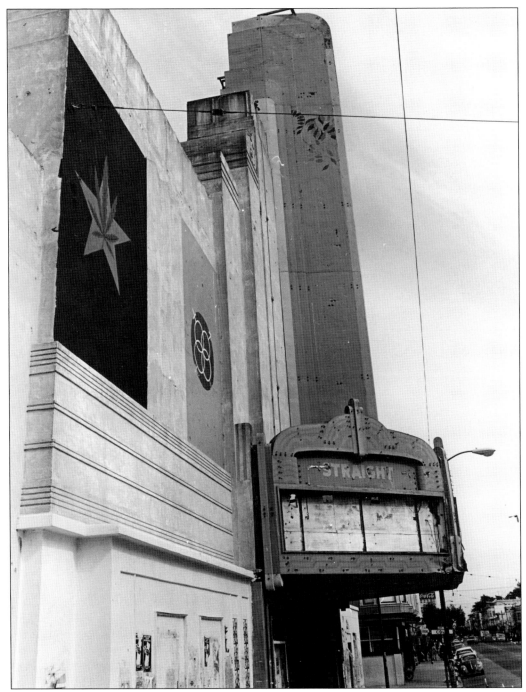

By the mid-1970s, the theater was shut up, and plans were made for demolition.

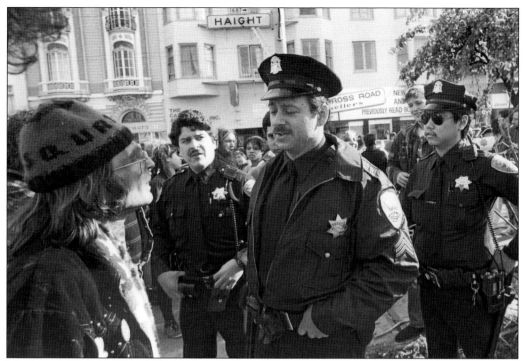

Haight residents began asking questions. The Park Station police once again were called upon to serve as peacekeepers and diplomats.

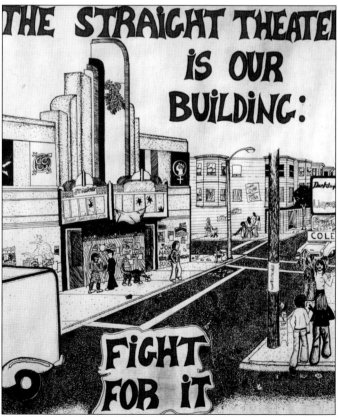

In a community famous for activism, residents started to move into action. This artwork, by "Greg," inspired more people to organize.

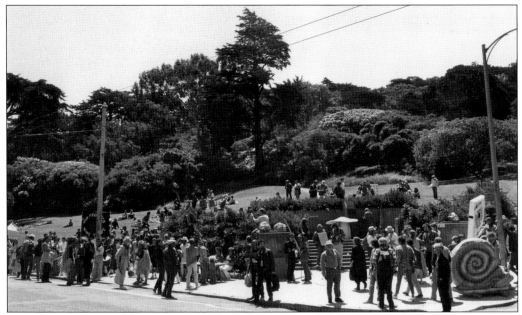

On a sunny day, neighbors gathered for a march from Buena Vista to the Straight Theater in protest of its closing.

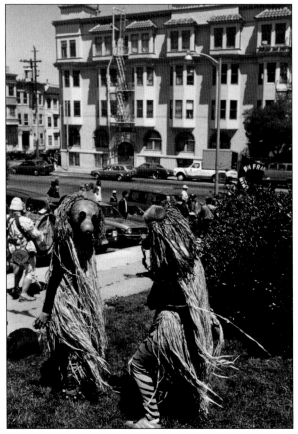

In the tradition of the Diggers, participants created impressive street theater. Dancers, costumes, and a bass drum turned a march into a parade.

People dressed for the occasion. Musicians included a guitarist.

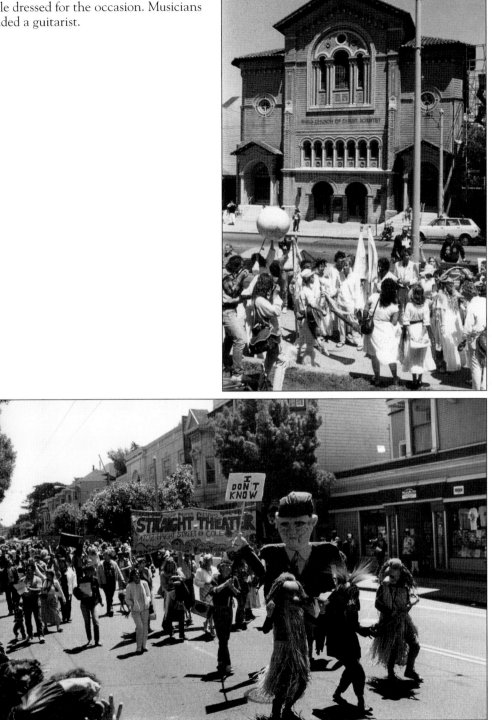

Participants proceeded up Haight Street to protest the razing of the theater. Here the procession approaches Masonic Avenue. Signs and banners identified the cause and made reference to statements by the landlord and others.

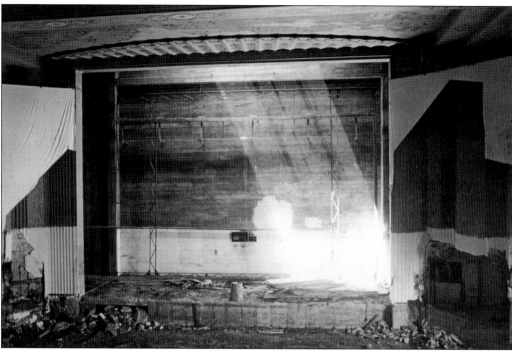

The architecturally remarkable Haight Theater—a venue for vaudevillian acts and boxing matches, then a grand movie palace, and in later years, a space for concerts and community events—was now being demolished.

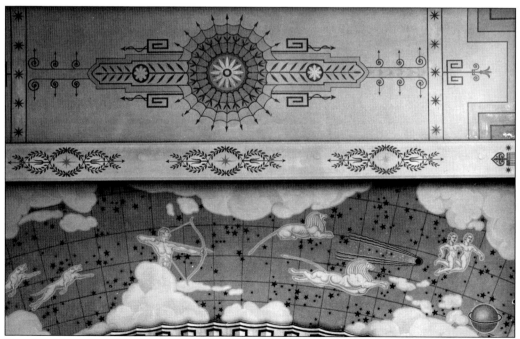

Details of the celestial bodies motif on the ceiling give an indication of the splendor of the Haight Theater's interior.

Community leaders and archivists observe the remnants of the Haight Theater. Most of the archival photographs of the theater's final days were taken by one dedicated (and rather private) man.

The impending loss of the Haight Theater was mourned by those who could imagine the history of theatergoers: 1920s audiences in trendy knee-length dresses, patrons of the 1930s and 1940s leaving in an aura of glamour after seeing *Top Hat* or *Love Affair*, and eager flower children in flowing skirts and colorful ponchos sharing the music of a cultural revolution.

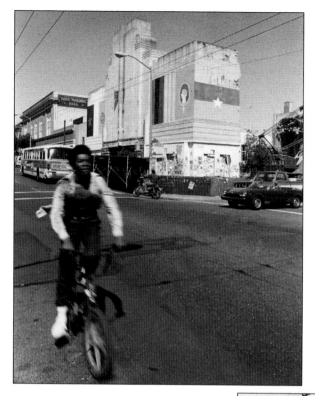

The neighborhood took a blow. Here a young Haight-Ashburian rides his bike past the condemned building that was once the jewel of his neighborhood.

Landlord John Brannan shows his face to the camera.

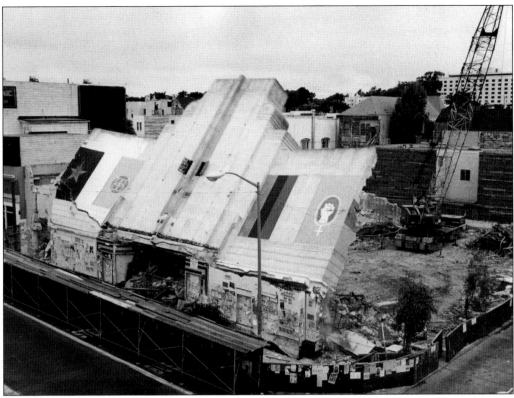

This photograph caught the facade of the Haight Theater on its final day.

The theater is reduced to rubble on an afternoon in 1979.

The demolition of the Haight Theater left a scar on the neighborhood. In a city known for its beauty, the abandoned lot stood out.

Poets and troubadours did not abandon the theater's former site, nor did Haight residents abandon their involvement in the community or in national and global activism.

Six

PEACE, LOVE, AND POLITICS

In the 1980s and 1990s, the Haight-Ashbury District continued to experience the reverberations of the Summer of Love. The Reagan administration and Margaret Thatcher's prime ministership espoused trickle-down economic theories and caused what seemed to many a harsh political landscape. People from various backgrounds interested in alternatives were still drawn to the Haight. Some had lifestyles similar to the families that were already established in the neighborhood, and some were drifters. As always, there were some residents who were uninterested in political activism and some who were.

In the 1980s, there were economically challenging times, and the city experienced a major earthquake which, once again, caused little damage in the Haight. The AIDS epidemic was especially devastating, and again All Saints Church responded, this time ministering to those who suffered and those who grieved. The Reverend Kenneth Schmidt was called to shepherd the congregation through this difficult period. In 1988, there was a celebration of the 20th anniversary of the Summer of Love.

The dot-com boom of the 1990s brought wealthy new homeowners to the neighborhood and drove many longtime residents out. Somehow, young people still found apartments to rent, but that became more difficult.

Through it all, Haight-Ashburians lived their everyday lives, some at the forefront of political activism for peace, equitable distribution of wealth, and basic quality of life.

Roberts Hardware and the Elite Shoe Repair Shop marked 60 years in the community, and the Haight-Ashbury Neighborhood Coalition, the free clinics, and the food program entered their fourth decade. Jerry Garcia's death in 1995 brought neighbors into the streets and pilgrims from around the world. In 1999, the neighborhood hosted the 22nd annual Haight Street Fair.

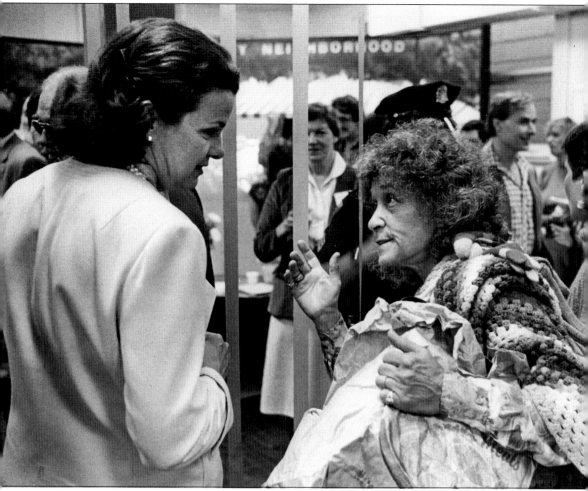

President of the board of supervisors, Dianne Feinstein became mayor of San Francisco on December 4, 1978, after Mayor George Moscone and supervisor Harvey Milk were shockingly assassinated in November. Feinstein served as mayor until 1988. Here she is seen on a visit to the Haight-Ashbury District.

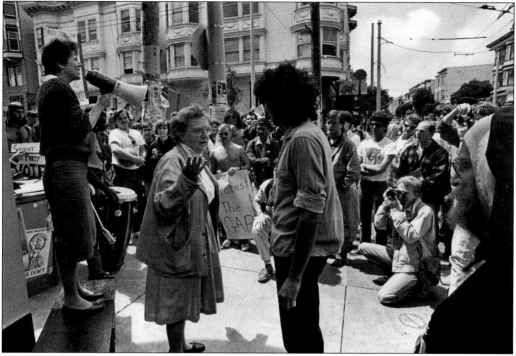

The presence of a GAP, which opened in the early 1980s on the southeast corner of Haight and Ashbury Streets, was a source of controversy. Visible in the lower right corner of this photograph is a member of the Sisters of Perpetual Indulgence community service and activist group. In 2008, the GAP closed and was replaced by an independent designer.

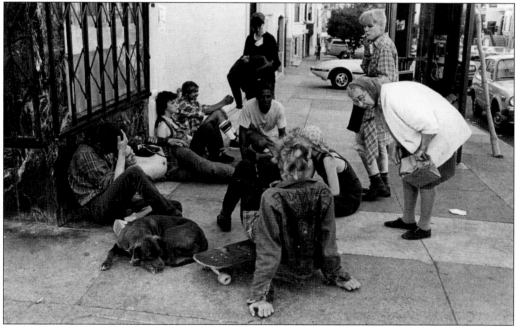

People continue to be drawn to the Haight-Ashbury District, and longtime residents continue to be challenged by the vagrancy of some visitors.

The Stanyan Park Hotel opened in the early 1980s, offering old-world charm and elegance to visitors.

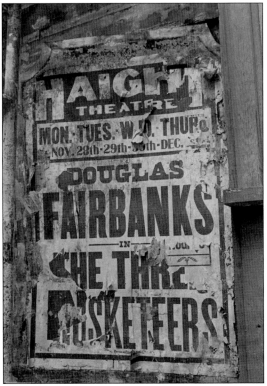

This movie poster from the glory days of the Haight Theater was uncovered when renovations were being done on a Victorian building on Stanyan Street at Waller Street. The wall where the poster was found is now covered by a large billboard.

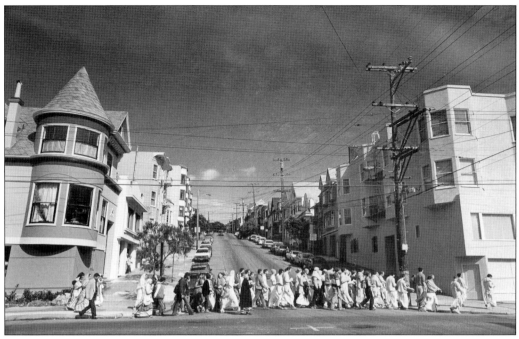

The Hare Krishnas were a colorful presence.

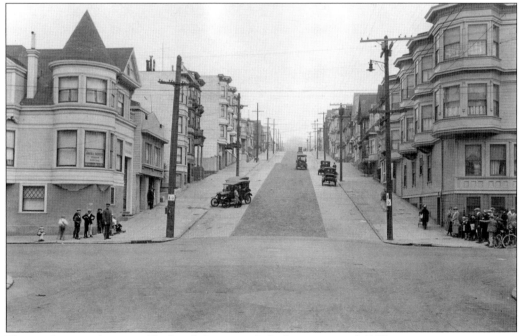

Here is the same location, Frederick Street at Cole Street, around 1925.

The White Panthers are a citizens' rights advocacy group. Ron Landberg, shown here talking with policemen, was a spokesman for the White Panthers, named in solidarity with the Black Panthers.

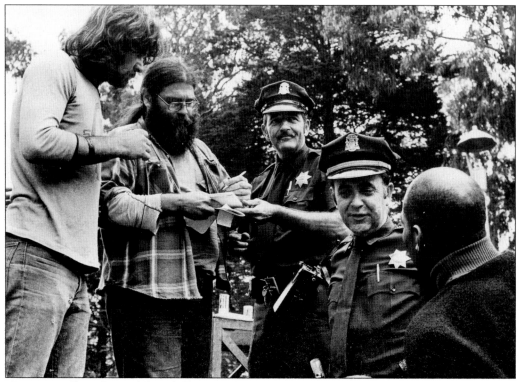

Here is Landberg (second from left) at a rally for squatters' rights.

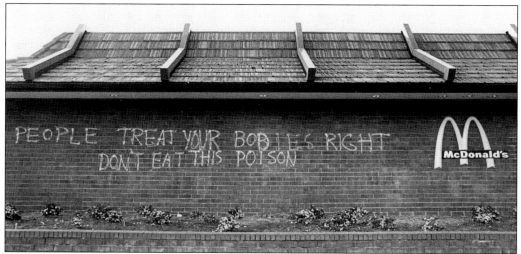

The opening of a fast food chain on the southeast corner of Haight and Stanyan Streets did not sit well with many Haight-Ashbury residents. This photograph displays an indication of long-held, non-mainstream sensibilities in the Haight.

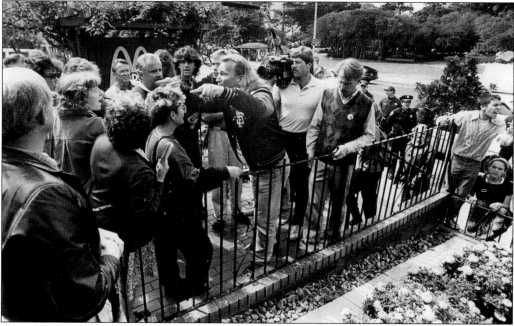

Pablo Heising (gesturing, center) was considered the mayor of Haight Street. His response to the new fast food presence at Haight and Stanyan Streets was to step forward in the interest of public health. Heising ran the Haight Street Fair from its inception in 1978 until his sudden death one December morning in 2006. At his favorite café, on Cole Street near Haight Street, he was stricken by a heart attack. Heising is remembered for his determined demeanor and generosity of spirit. He embodied and acted on values that he had seen flourish during the Summer of Love, continuing to effect peace and enjoyment and to question mainstream conventions. The fair helped to revitalize the neighborhood, which languished after the Summer of Love, and in 2006, Heising organized a daytime Halloween festival focused on fun for children. Both the fair and the Halloween Hootenanny continue as part of Pablo Heising's legacy.

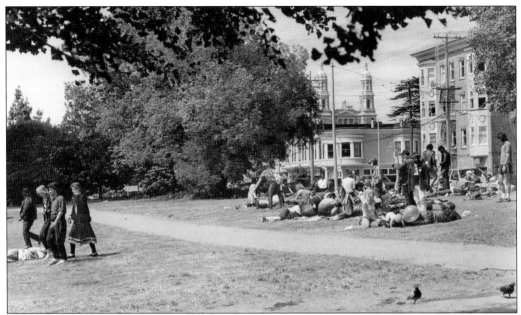

Shown here in 1983, the area near Alvord Lake at the entrance to Golden Gate Park had changed its aspect. A supermarket and fast food outlet replaced the hotel and amusement attractions of yesteryear. The pillars and plantings at the entrance were redone in the 1990s, and neighbors regularly attend organized maintenance parties where people of a variety of ages and walks of life pitch in.

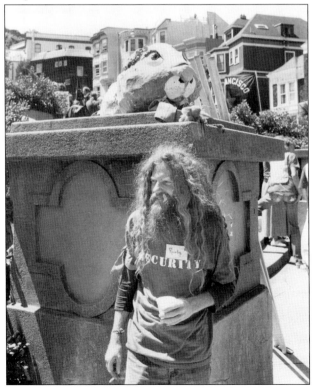

Pictured here is a sunny morning at Buena Vista Park, Victorian houses decorating the hillsides. The Haight Street Fair, street theater, and friendly but effective security are major components of a good time in the Haight.

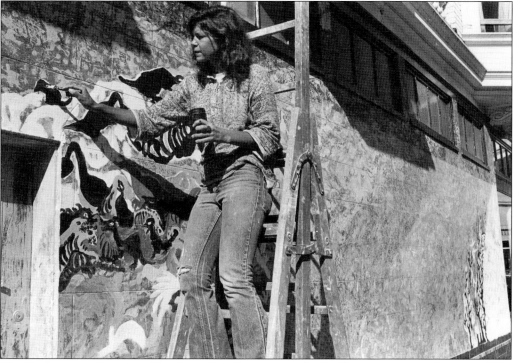

The Evolutionary Rainbow Mural on Cole Street near Haight Street was painted over in 1982. The furor that ensued inspired the building manager, Ed Camp, to arrange for the mural to be uncovered. The muralist, Joana (Yana) Negri, painstakingly restored her work.

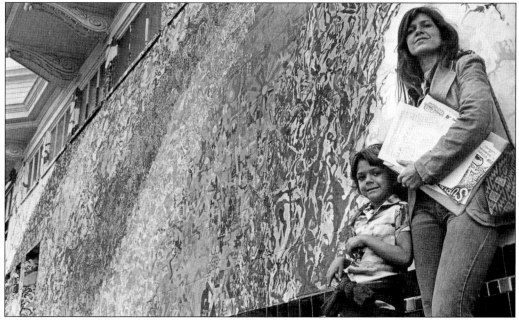

The rainbow mural now has landmark status and is also protected under the Art Preservation Act, which guarantees such a work's existence for 50 years after the death of the artist (pictured here with her son).

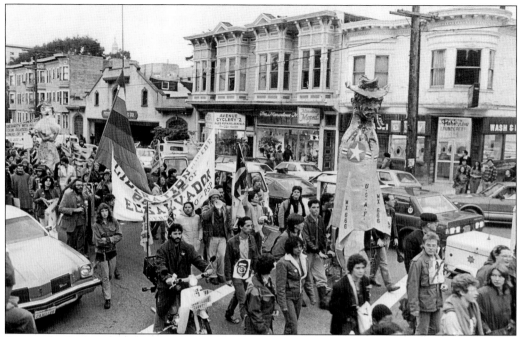

Queen Elizabeth II's 1983 visit to San Francisco during a tour of California with then-Pres. Ronald Reagan prompted a large protest in Golden Gate Park. Marchers crossed Page Street at Stanyan Street before entering the park carrying signs decrying the Reagan administration's dealings in El Salvador.

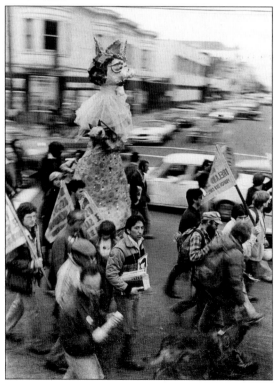

In addition to a papier-mâché figure of Reagan dressed as a warhead, this likeness of the queen was included.

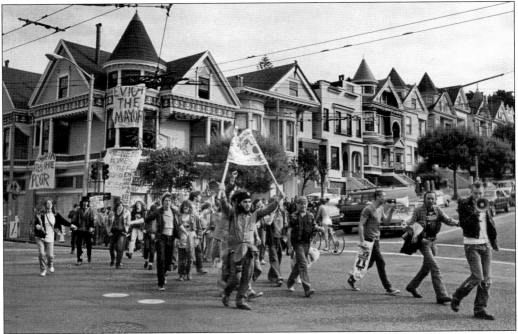

As property values and rents rose in the Haight-Ashbury District, people struggled to stay in their homes. During a march and rally, someone hung a banner reading "evict the mayor" from a window at the southeast corner of Haight Street and Masonic Avenue.

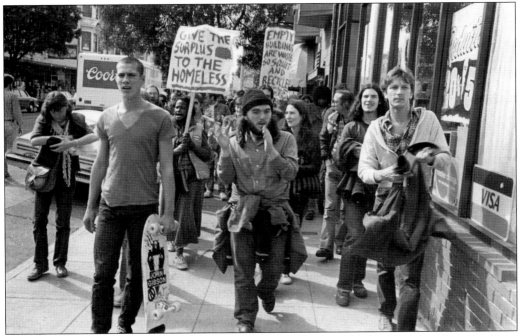

The reverberations of Ronald Reagan's dismantling of Roosevelt's New Deal and much of the infrastructure of Lyndon Johnson's Great Society, such as school lunch programs and payments for people with disabilities, are still being felt today. These marchers on Haight Street offer a specific proposal for improving the state of the nation.

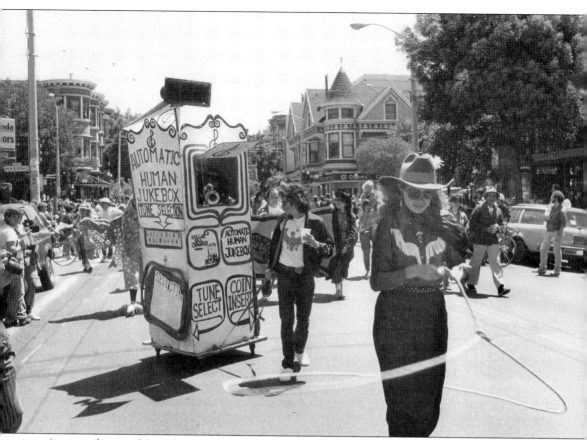

Against the usual backdrop of Victorian buildings, Haight-Ashburians celebrate life. Here the internationally hailed musician Grimes Poznikov plays his trumpet as the Automatic Human Jukebox. After showing up at the draft board high on acid, and after being arrested at the 1968 Democratic convention while playing "America the Beautiful" on the trumpet, Poznikov settled in San Francisco. Sadly, he died in 2005 after suffering for an extended time. From the toot on a kazoo in response to small donations to the gloriously beautiful renditions of standard favorites that came with a couple of dollars, Grimes Poznikov's musicianship delighted thousands.

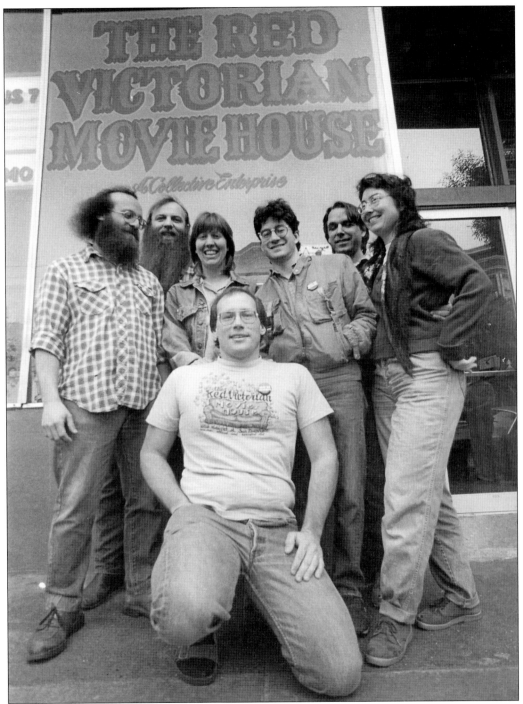

Now in its second location on Haight Street, the Red Victorian Movie House, founded by these visionaries as a cooperative venture in 1986, is still going strong. Moviegoers can choose from sofas or theater seats and see Fellini films, animation festivals, Harry Reasoner in the 1967 "Hippie Temptation" report, Woody Allen movies, international documentaries, *Saturday Night Fever*, and an array of other cinematic treats.

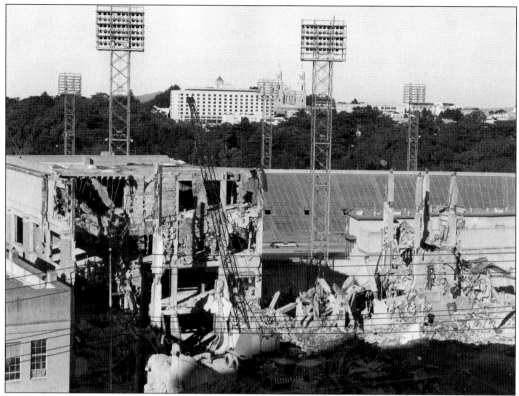

In 1987, the building that had housed San Francisco's Polytechnic High School was torn down. Kezar Stadium, which stands across Frederick Street, would be demolished and reconstructed in 1989.

On the site of Polytechnic High, the city erected Parkview Commons, affordable condominiums. Here Mayor Art Agnos (1988–1992) makes the project official.

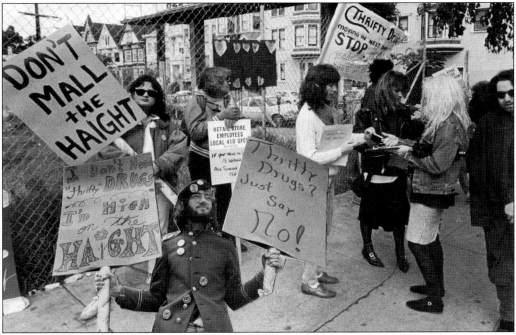

The corner of Haight and Cole Streets became a locus for contention for at least a second time when, in the late 1980s, a Thrifty Drugs chain store was about to be erected. This montage shows concerned citizens protesting the threat to local businesses on the site of the old Haight Theater.

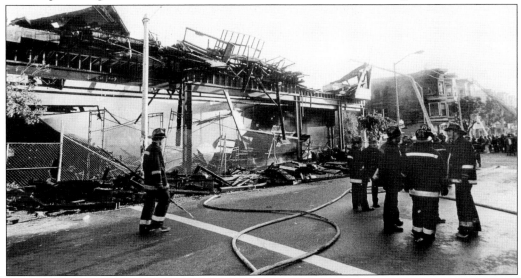

On September 22, 1988, a fire did major damage at Cole and Haight Streets. The construction of the Thrifty Drug was permanently halted. That corner is now home to a Goodwill store, where neighbors and visitors from many walks of life bring their unwanted items and often find treasure in another's trash. Further west along this block, where the theater once stood, retail shops occupy the ground floor below apartments constructed in 2003. The landlord's early-21st-century changes to the site resulted in the loss of Truly Mediterranean, a restaurant where locals, parents with small children, students at the posh and progressive Urban School, and tourists enjoyed outstanding food and happy international relations.

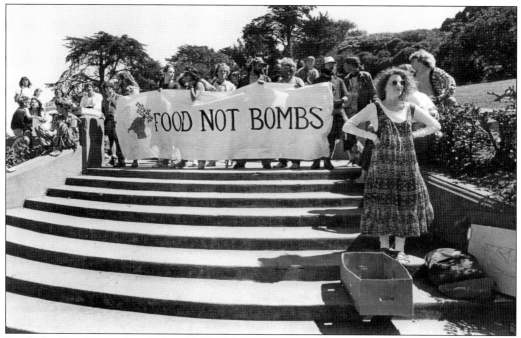

Food Not Bombs was founded in 1980. Volunteers recover discarded food and serve vegetarian meals in outdoor public spaces and at peace rallies. On August 15, 1988, nine Food Not Bombs volunteers were arrested at the Stanyan Street entrance to Golden Gate Park while giving out free food. The city went on to make over 1,000 arrests, and Amnesty International declared these volunteers "prisoners of conscience." This gathering is at the northwest corner of Buena Vista Park.

A man and a boy work a plot of earth in one of the neighborhood planting projects.

A pickup basketball game at Grattan Park is played against the backdrop of Ashbury Heights and Buena Vista Hill.

In the 1980s, before the relocation of the Independence Day fireworks display to the Embarcadero, neighbors gathered atop Buena Vista Hill (569 feet above sea level) to enjoy the show. It was from Buena Vista that Katherine Sutter and her family watched the city in flames following the 1906 earthquake. As was true in 1906, the Haight-Ashbury District received very little damage from the Loma Prieta earthquake of October 1989.

Since the 1970s, the Booksmith has served the literary needs of Haight-Ashburians, including hosting an ongoing celebrated events program. Allen Ginsberg gave his last reading at the Booksmith.

Sami Sunchild purchased the building at 1665 Haight Street, where she eventually opened the Red Victorian Peace Center, a bed and breakfast, shop, and café, and the home of the Peaceful World Foundation. Here the chef takes a break.

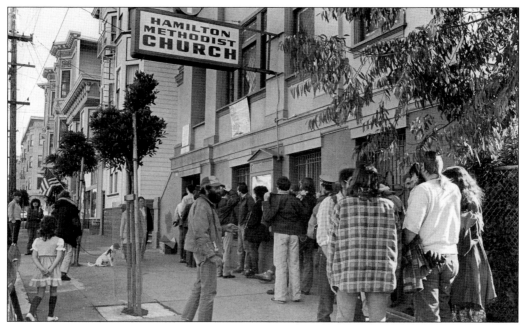

Until spring of 2008, when it closed its doors, the Haight-Ashbury Food Program provided food for the hungry, as well as a culinary arts program. Each Thanksgiving, neighbors of all ages gathered to serve and be served, and volunteers welcomed, sat, and served diners. According to the *Haight-Ashbury Beat*, the rebirth of the food program is anticipated by many. As reported in the *New York Times*, in many parts of the country, including some cities, when needs are not met, local governments send the down-and-out away with a one-way bus ticket to San Francisco. Many of those people come to the Haight, where groups such as the Haight-Ashbury Free Clinics and others like the now-disbanded food program attempt to address their needs. The Haight-Ashbury Food Program was housed in the Hamilton Methodist Church, whose building was designed by Julia Morgan.

In 1999, the Haight celebrated the 22nd annual Haight Street Fair. Mona Caron's winning watercolor was the poster that year. It incorporated Victorian architectural details, such as Queen Anne towers and Italianate eaves, the dove and olive branch as symbols of peace, and a girl holding objects of fancy and well-being.

113

The Haight-Ashbury Neighborhood Coalition's (HANC) recycling center and native plant nursery is a vital part of the neighborhood. Pictured here is a member of the hardworking staff. Founded in 1959, HANC launched a successful attempt to prevent the Golden Gate Park Panhandle from being blighted by an expressway. Since then, the coalition has been a strong presence in the community.

Here some "San Francisco values" come together: concern for the environment and how we consume and discard, support for strong public education, and cooperation meet at the recycling center, an important place for everyone, including those who earn a bit of much-needed cash there.

Seven

POPULAR DESTINATION, REFUGE, AND HOME

In 2000 the Haight-Ashbury District was still home to many longtimers, including people who had settled in the post-war period, flower children who had made the Haight their permanent home, those who had purchased homes during the "recovery period" of the 1970s, latter-day flower children content to forgo equity and set down roots in apartments in this extraordinary place, and people who had made a windfall during the dot-com era. According to a report by the board of tourism, Haight Street was the second-most-visited destination in the city after Pier 39. On Haight Street, a father and child taking produce home from the selective Haight Street Market might exchange smiles with tourists from Germany. A Tibetan shopkeeper might show pictures of his new baby to a regular customer who was raised in Jordan. Scruffy young people might ask for change—in every sense of the word—from well-heeled students from the Lycée Français La Pérouse up the hill. The neighborhood thrives on a harmonious plurality.

Immediately after the events of September 11, 2001, a walk through the neighborhood testified to the diversity of its inhabitants' sensibilities. As was true in the rest of the country, there were flags flying. In the Haight-Ashbury District, some were the Stars and Stripes and some were simple depictions of our blue planet on a white background. In the bay window of an apartment at the corner of Ashbury and Waller Streets hung a big peace sign made from a string of white party lights. One family put a sign on the door of their Victorian home that read, "We Still Love New York." People wore "I Love NY" t-shirts. Over the next few years, "Support the Troops" and "Peace is Patriotic" bumper stickers began to appear.

The neighborhood's calendar continued to be marked by the Grattan School Fun Fest in May, the Haight Street Fair in early June, the departure of many brave souls for the Burning Man festival around Labor Day, and the Belvedere trick-or-treating wonderland. The first annual children's Halloween Hootenanny was organized by Pablo Heising in 2006 and was a success again in 2007, and the first Children's Alley at the Haight Street Fair was inaugurated with Chinese lion dancing in 2008.

The SFFD station's aerial truck is identified as belonging to the Haight-Ashbury District by the Grateful Dead "Steal Your Face" skull image incorporated into its seal. Students from Grattan School enjoy field trips to the station, and the truck is a regular at Grattan events and other community occasions. (Photograph by the author.)

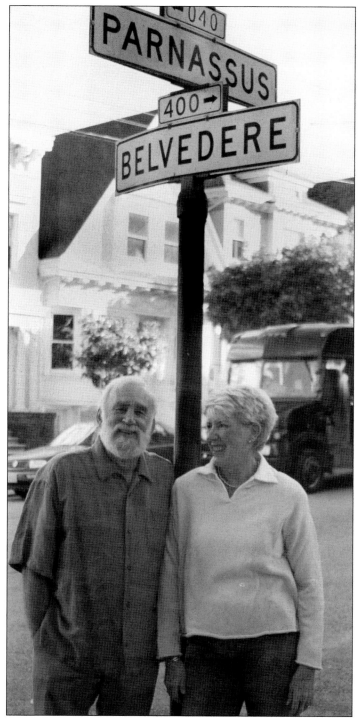

Bruce and Marie Samson, longtime residents, pose happily at the corner of Parnassus Avenue and Belvedere Street. They are the owners of the Kids Only boutique, and they were among the first to participate in what has become an elaborate trick-or-treating event on Belvedere Street. (Photograph by Jeremy Bates.)

Christine Brown has lived in the Haight-Ashbury District since she came here as a bride in 1953. With her late husband, Clarence, who was known as "the Mayor of Masonic Avenue," Christine Brown inspires her neighbors to maintain the beauty of the neighborhood and especially to display stunning holiday lights and decorations, of which newcomers are notified when they take up residence on the block. (Photograph by Jeremy Bates.)

Kostantinos "Gus" Vardakastanis stands before his family's Haight Street Market. Gus and his family are cherished friends among Ashburians and make a myriad of contributions to the neighborhood. (Photograph by Jeremy Bates.)

Artist, father, friendly neighbor, and hardware expert Stan Flouride had a show of his velvet paintings at the People's Café in 2006. (Photograph by Jeremy Bates.)

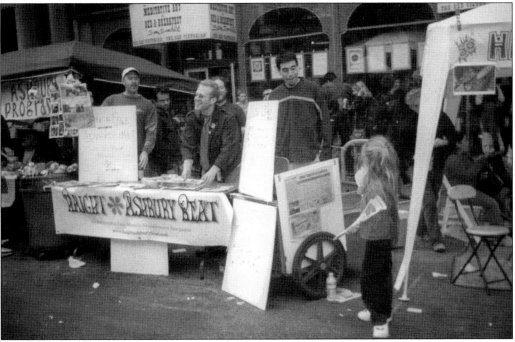

Jeremy Bates, center, purchased the languishing *Haight-Ashbury Beat* newspaper in 2005. At the 2007 Haight Street Fair, the *Beat* booth was next to the Haight-Ashbury Food Program booth in front of the Red Victorian Peace Center. (Photograph by the author.)

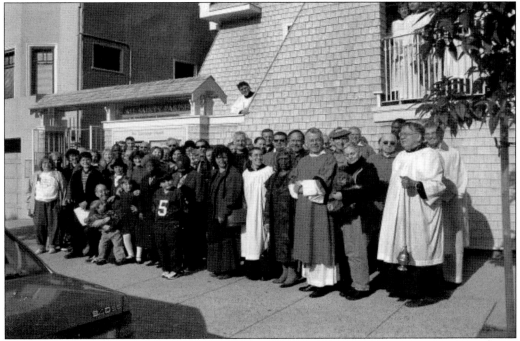

The congregation and clergy of All Saints Episcopal Church gather before their newly renovated building. In 2005, the church celebrated its centenary. (Courtesy of All Saints Episcopal Church.)

These daughters of the Haight-Ashbury District were photographed at a party in summer 2007 to celebrate an impending marriage. Pictured here from left to right are three unidentified neighbors, the author's daughter, and the daughter of David Wills, the artist who created the first Haight-Ashbury Street Fair poster. (Courtesy of Marie Sayles.)

In 2007, the popular American Girl company issued the Julie Albright doll. Joining other 20th-century figures like Depression-era Kit Kitteridge and World War II doll Molly McIntire, Julie represented the 1970s. Julie's backstory was that she moved with her mother and sister to the Haight-Ashbury District in the mid-1970s when her parents divorced. This native Haight-Ashburian poses on Masonic Avenue near Haight Street with her Julie doll, a Christmas gift. The fictional Julie was born in 1964; the child's mother was born in 1962. (Photograph by the author.)

During the winter of 2007–2008, a fierce wind and rainstorm wreaked major damage in the neighborhood. Branches fell onto cars, and some trees, such as this one on Masonic Avenue near Frederick Street, were uprooted. (Photograph by the author.)

No matter the weather, Jacob Alexander walks each and every day from the home he shares with his wife, an artist, to the far end of Golden Gate Park near the Pacific Ocean, a distance of about four miles. Along the way, Jacob greets and is greeted by neighbors and strangers, children and adults. His spirit is an inspiration to the neighborhood. (Photograph by Jeremy Bates.)

After the 1906 earthquake, much of the city experienced such devastation that people easily became disoriented for lack of familiar landmarks. As a result, the city began engraving the street names into the sidewalk at intersections. Over the years, repaving has created interesting reconfigurations, such as this one. (Photograph by the author.)

In 2008, at the 31st annual Haight Street Fair, Haight-Ashbury children stroll together in the company of their mothers. In the background is the sign for Roberts Hardware, which marked its 77th anniversary. Change and continuity go hand in hand in this extraordinary neighborhood. (Photograph by Jeff M. Cohen.)

INDEX